IMAGES
of America

OZARK

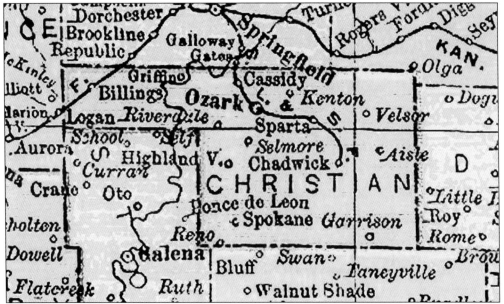

Ozark was established 150 years ago, and was built upon a philosophy of life that is shown in Ozark's slogan: "Progress with Pride." Ozark is located at the crossroads of Highway 14 and Highway 65, "Nestled between the hills of the Aux Arcs Mountains and snuggled up close to the Finley River," as the Ozark Chamber of Commerce says. Ozark was officially named the county seat in April of 1859. (Map from 1895 U.S. Atlas. Courtesy of the MARDOS Memorial Library; Permission granted by Pam Rietsch.)

IMAGES
of America

OZARK

Michelle Korgis-Fitzpatrick

ARCADIA

Published by Arcadia Publishing,
an imprint of Tempus Publishing, Inc.
Charleston SC, Chicago, Portsmouth NH,
San Francisco

Printed in Great Britain.

Library of Congress Catalog Card Number: Applied For.

For all general information contact Arcadia Publishing at:
Telephone 843-853-2070
Fax 843-853-0044
E-Mail sales@arcadiapublishing.com
For customer service and orders:
Toll-Free 1-888-313-2665

Visit us on the internet at http://www.arcadiapublishing.com

Contents

ACKNOWLEDGMENTS

The photos and information in this publication are from the Pegram Collection on the website, http://library.drury.edu/OFP, "Ozark Folk Life Project." Permission was granted by Dr. Bruce Pegram personally along with Victoria Johnson, F.W. Olin Library, Drury University. This includes permission granted by Mable Phillips, Librarian of the Christian County Library and the Libraries website [http://rootsweb.com/~moccl/]. Also, a great thanks to the Christian County Historical Society.

Special thanks to both Dr. Bruce Pegram and Victoria Johnson for the photos and the information.

Great thanks to both my husband, Chris Allen Fitzpatrick, for the encouragement and the incentive to finish this book, and the rest of my family and friends.

In addition, a great thanks to those in my writer's group, the Springfield Writer's Guild, for their encouragement. This includes my great thanks to Warren Dunham for the cover photo.

As an historical writer, I will continue to accept photos, papers, memorabilia, oral history, and such for future publications on different towns in Christian County.

All additional information, photos etc. can be sent directly to me at: Michelle Korgis-Fitzpatrick, PO Box 553, Nixa, MO 65714-0553.

I hope this book will help to preserve the memories of our history now and into the future.

I would like to add that I have made an attempt through research to be as exact and precise as possible with the dates and information noted in this publication. Should any reader find inaccurate notations, please send a letter providing the correct information to the above name and mailing address.

INTRODUCTION

The history of Ozark dates back as early as 1818 when the first American explorer, Henry R. Schoolcraft, explored the area. Two years later, in 1820, the first settlements began to take shape in the immediate area and around the James and Finley Rivers.

In 1833, James Kimberling Sr. built the first mill in Ozark. Kimberling's mill was known later as Hoover's Mill. Another man named Eustler established a store around the same year. Later, Eldridge opened a blacksmith shop and so these three establishments began the growth of commercial industry in the area.

The sale of town lots began in 1843. The town was laid off, J.C. and A.N. Farmer sold the lots, and A.N. entered a 40-acre tract on May 25, 1840. This was later known as the "Old Town." A.N. Farmer entered the present business district of Ozark on July 17, 1845. The Town Square was located on top of Eutsler Hill in 1843, and the townspeople got their water at the foot of the hill, from Bluff Springs. Later, the highway was filled in on part of this spot and the spring became almost inaccessible. Two men hauled barrels of water to the people of the community for ten cents a barrel after the new town of Ozark became established.

In 1855, more settlers arrived in Ozark. A few more general stores and blacksmith shops opened, and grist and saw mills were established, as well as a drug store, a saloon, and a store called Turner where saddles and harnesses were made. The first known doctor in the area was N.A. Davis.

Ozark is the oldest town in Christian County, Missouri. It was officially named the county seat in April 1859—because of its central location and accessibility—just a month after the establishment of Christian County.

On March 5, 1860, J.C. Inman surveyed and laid out the new town and a public sale of land was held. About the same year, a two-story frame courthouse and jail was built north of the Square. On August 20, 1865, the courthouse was destroyed by fire and damaged all the files. The fire was caused by two cousins, one of whom had an indictment pending against him. In May of 1866 it was ordered that a new courthouse be built in the center of the Square.

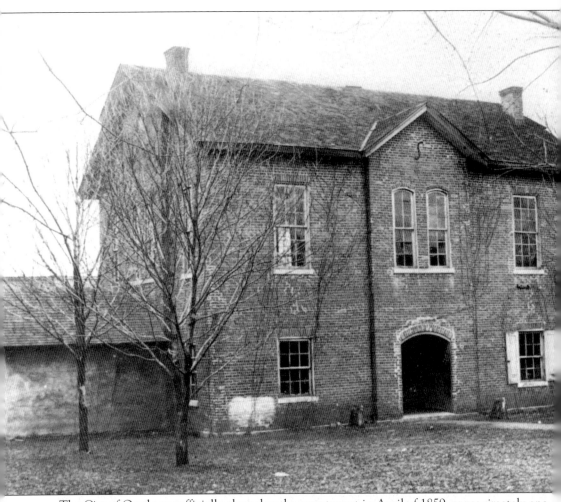

The City of Ozark was officially elected as the county seat in April of 1859, approximately one month after the establishment of Christian County, Missouri. Ozark had an ideal location in the center of the new county. In 1860 the first courthouse was built north of the Square. It was a two-story frame building with the courtroom on the first floor and offices on the second floor. On August 20, 1865, two cousins set fire to the courthouse destroying all records along with the building. One of the men responsible had an indictment pending against him.

One
THE SQUARE

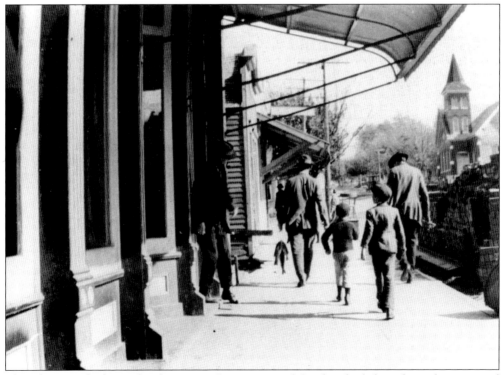

This photograph shows the downtown Square area of Ozark, which has always been a good gathering place that is well-used.

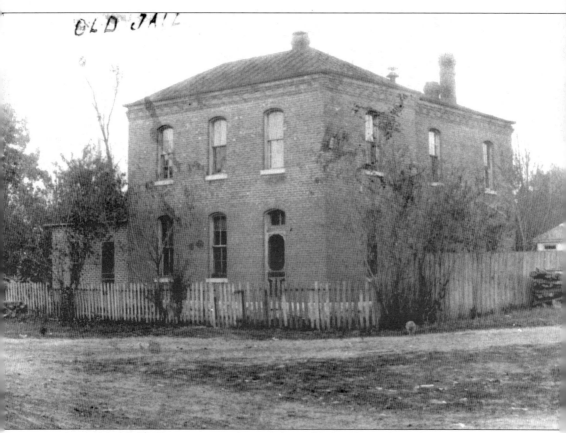

This jail held the four main members of the Bald Knobbers clan, who were sentenced to be hung. These men were Dave Walker, William Walker, Wiley Mathews, and John Mathews, who all were charged with the murders of William Eden and Charles Greene. Additional charges were also filed against them. In January of 1889, John and Wiley Mathews escaped from jail. John was captured, but Wiley was never found. On May 10, 1889, Dave Walker, his 17-year-old son William Walker, and John Mathews were all hung.

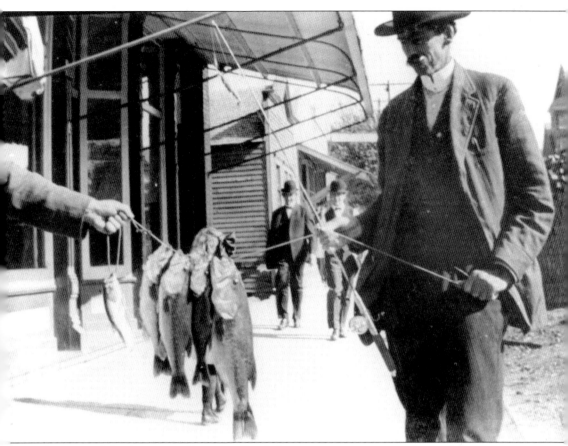

Another view of the downtown Square in Ozark shows two men returning from a fishing trip.

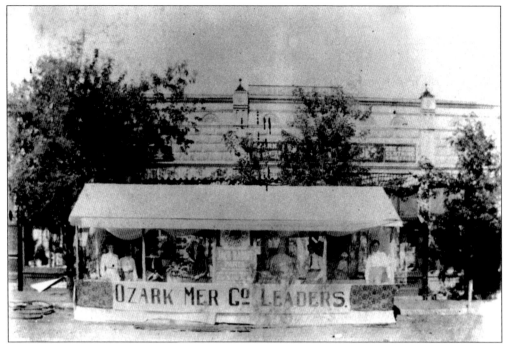

This was a booth located on the Ozark Square, put there for some type of event. On the big banner below the little sign it reads, "Ozark Mer Co Leaders."

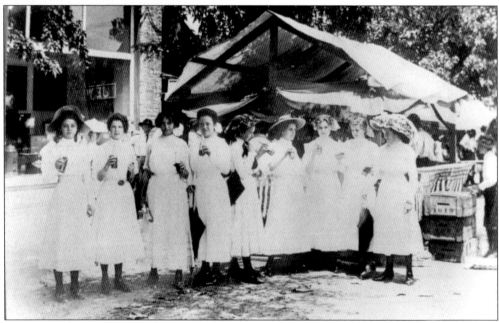

Located on the Square, another booth is seen here, along with these nine women who were drinking Coke.

12

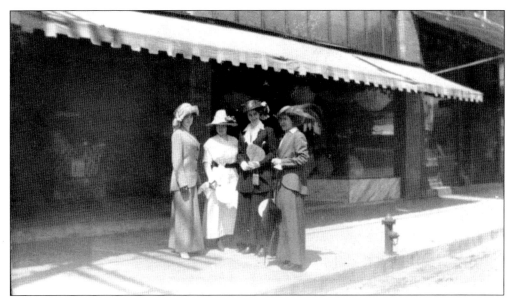

These four women stood on the Ozark Square in front of one of the old businesses, with their hats, fans, and parasols.

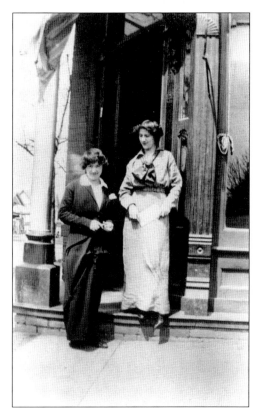

Here is another view of the Square with two women standing in front of a business.

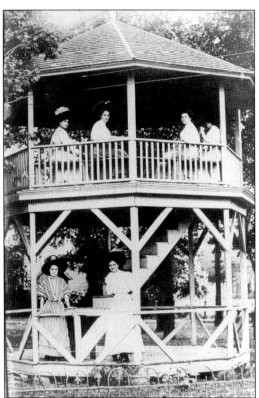

This was the gazebo in Ozark located on the courtyards. It was often decorated with flags and red, white, and blue cloths. It was used for political and local meetings, speeches, band concerts, and such.

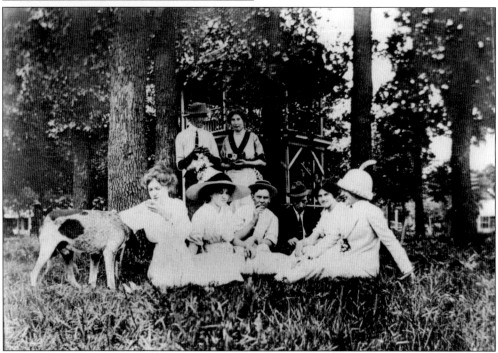

These men and women sat on the Ozark Square courtyard lawn. In the background, you can see the gazebo.

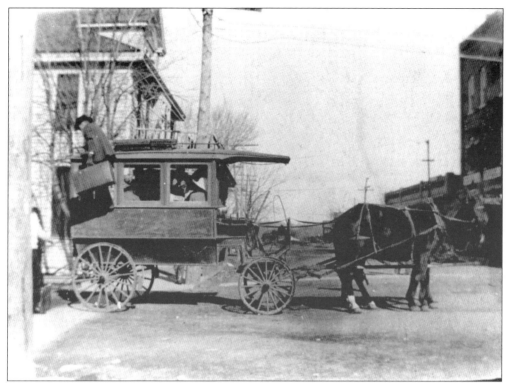

This is half of a post card showing the old Frisco Hack and the Smith Hotel. There was a cow tied in back that they used for milk. This buggy was on the old Ozark Square.

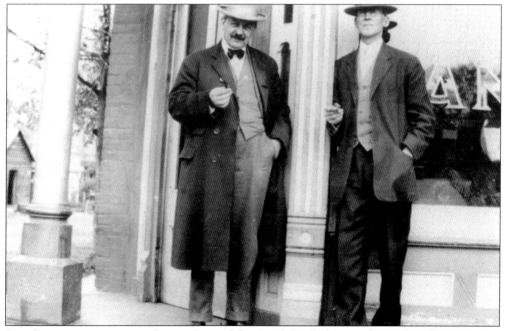

Seen here are two men standing in front of the Ozark Bank that was located on the Square.

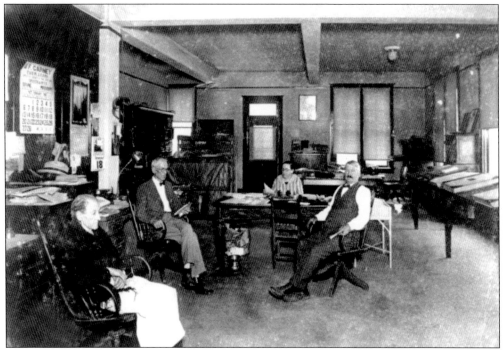

These people are inside an old office that was located on the Square in Ozark. The wall calendar reads February 1927 and shows the 18th on a Friday, whereas the smaller calendar shows Wednesday the 18th.

Dr. J.C. Young and Jack Clayman showed off their trophies of fish. They stood by the pharmacy, which in 1988 was the Countryside Cafe and was across the street from the Regal store were Dr. Bruton's office had stood.

Two
FORMER BUSINESSES

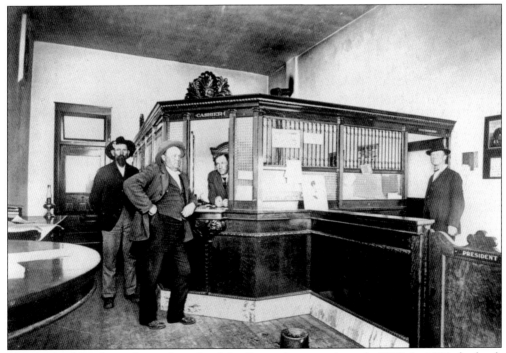

The Bank of Ozark was located north of the Square in approximately 1909. In 1933 the bank closed after it had served the community of Ozark for nearly 24 years.

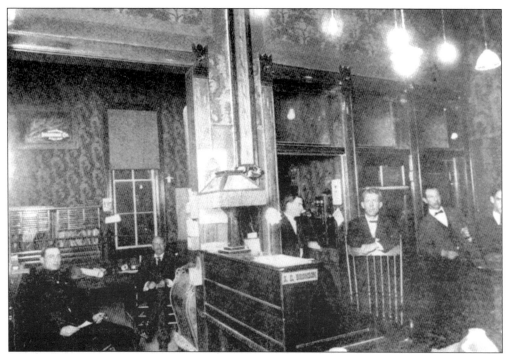

This is the inside office of the Ozark Power Plant in 1909. This building was the old Masonic Building.

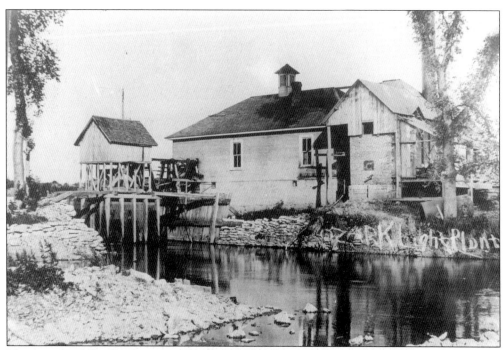

The outside of the Ozark power plant in seen here in 1909. It was located west of the Ozark Square, and many of the men from town would come here to play poker and craps. Frequently these games would turn into fights.

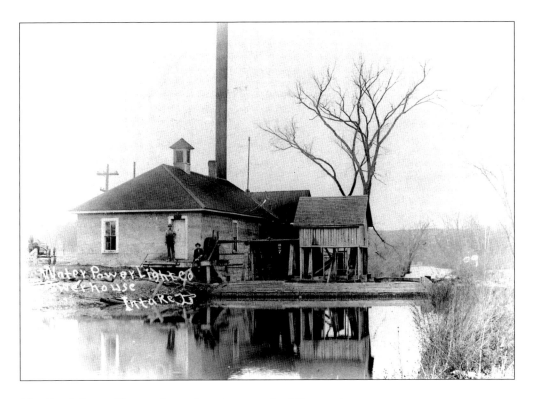

The Ozark Power Plant is shown here in a couple different views.

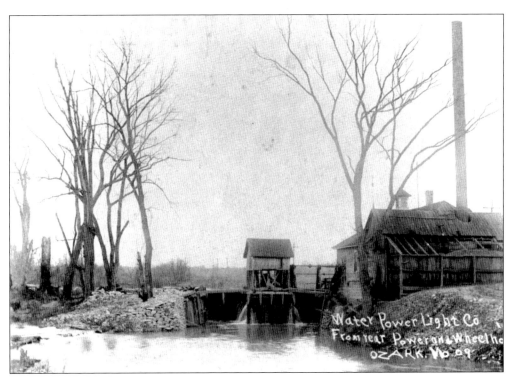

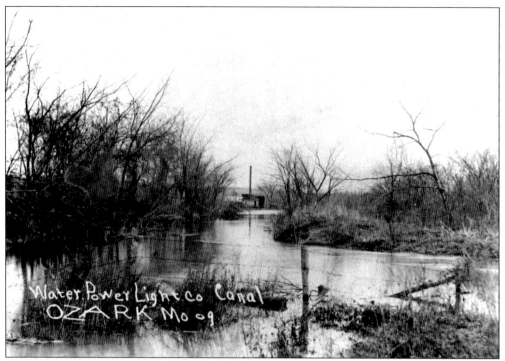

The Ozark Power Plant Canal was built on the Finley River.

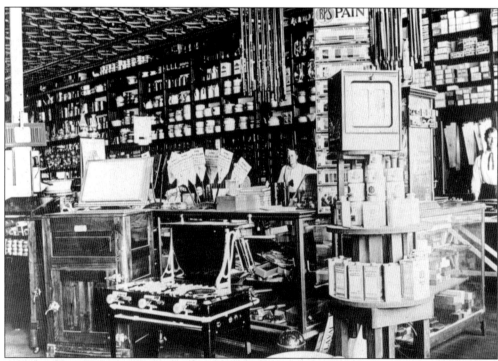

The Bringham Hardware Store was located on the west end of the Ozark Square. The inside of the store is seen here.

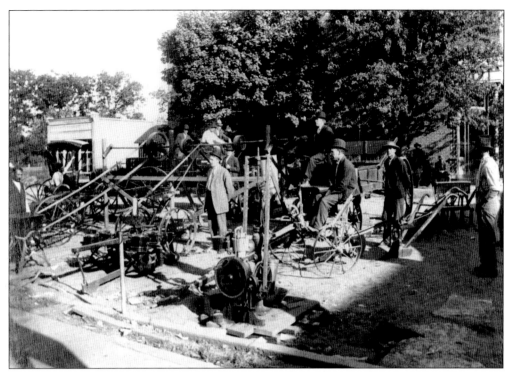

The J.W. Wray Lumber and Hardware company was located in Ozark.

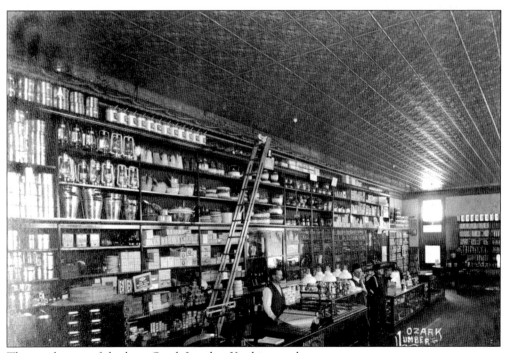

The inside area of the busy Ozark Lumber Yard is seen here.

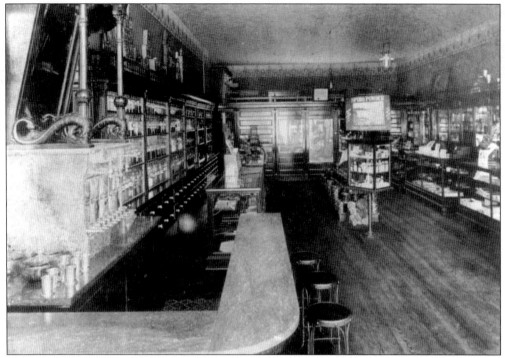

The interior of the Snider Drug Store in Ozark is seen here in 1904.

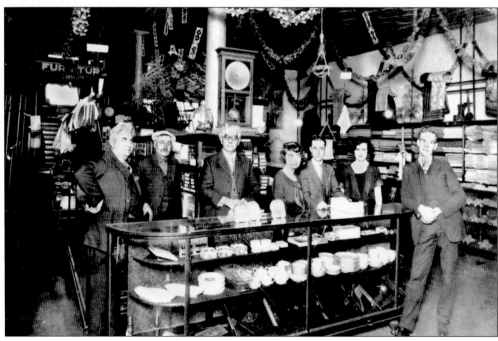

This 1925 photograph shows the inside of the Mercantile Store.

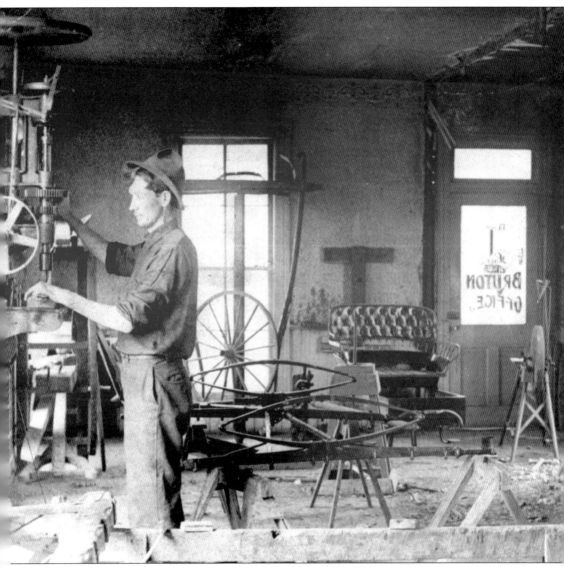

Ernest Williams was originally the Pharmacist but quit the pharmacy because he didn't like the large amount of alcohol that was given out. After quitting the pharmacy, he began working at the Bruton Buggy Shop. The inside of the buggy shop is seen here. The pharmacy was located behind this shop on the southwest corner of the Square.

The Smith Hotel, which was known also as the City Hotel, started out as the Wrightman Hotel on January 13, 1846. The hotel was located at the northwest corner of the Square. This hotel is remembered as a family style restaurant which later was operated by Art and Roxie Smith. For only fifty cents you were able to get an all-you-can-eat meal. The hotel did its best when Ozark was a railroad town. After the death of Art and Roxie Smith, the place was passed on to their daughter-in-law. A livery stable, dry goods store, and jewelry store were also located around this hotel.

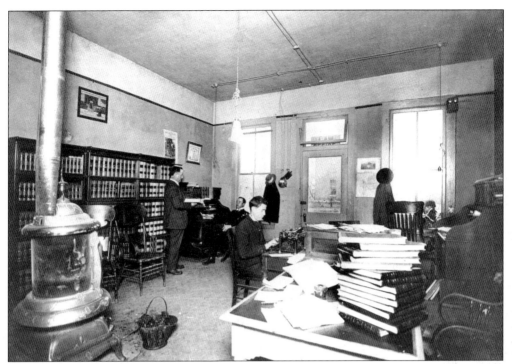

Located on the south side of the Square was the old law office, whose interior is seen here. Later in 1989, this office became the Doran Insurance Company.

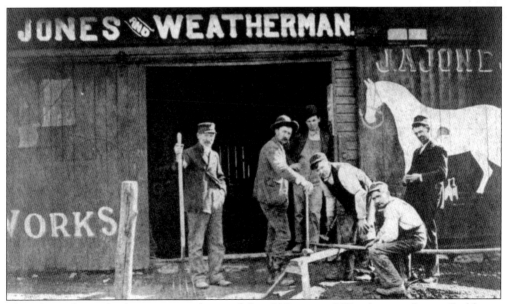

This photo shows the front sectioned area of the old Jones and Weatherman Livery Stable.

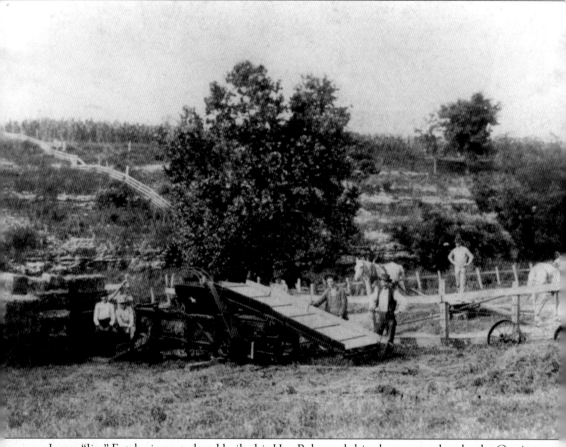

James "Jim" Eutsler invented and built this Hay Baler and this photo was taken by the Garrison Branch from Eutsler Hill. The papers that recorded the invention as being created by Jim were lost or stolen. Because of this, he never got the patent. Gene Williams of Tulsa, Oklahoma, was the last known family member to have this in his possession.

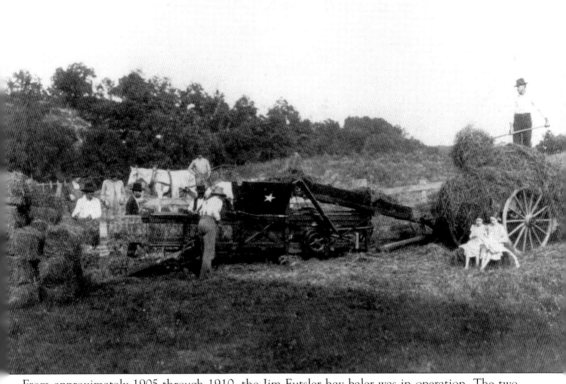

From approximately 1905 through 1910, the Jim Eutsler hay baler was in operation. The two girls are May (or Mary) Eutsler and Glessie (Cupp) White. Jim Eutsler was the grandson of John and Elizabeth Hoover who were the first mill owners. In the 1830s, Jacob Eutsler was the owner of the store that adjoined the mill.

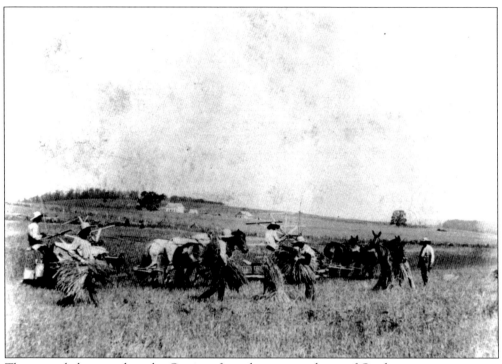

These people harvested on the Garrison farm that was northeast of Ozark.

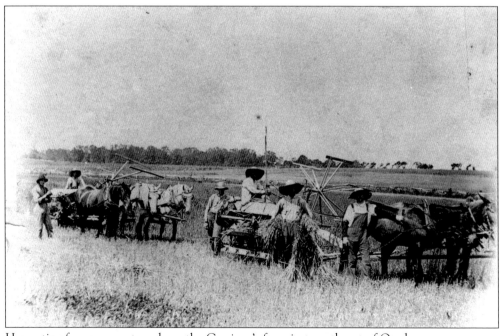

Harvesting farmers are at work on the Garrison's farm just northeast of Ozark.

Three

MILLS

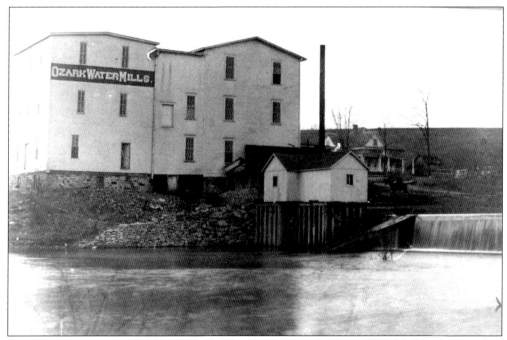

Seymour Chapman and Jim Tindle built The Ozark Water Mills in 1900. J.L. Hawkins worked for the Ozark Water Mills in 1902.

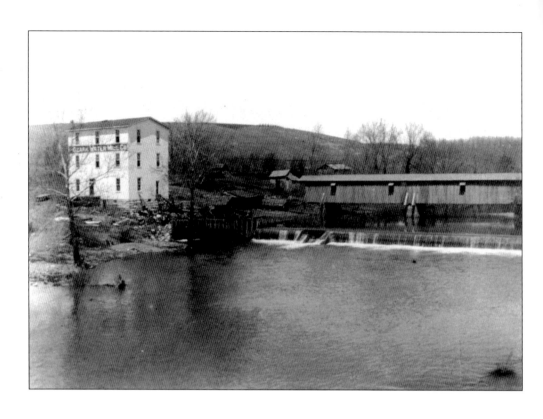

More views of the Ozark Water Mills are seen on this page and the next two pages.

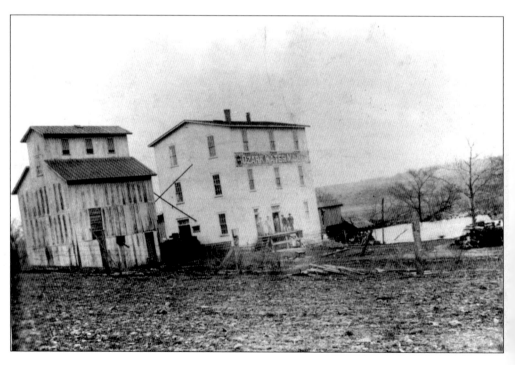

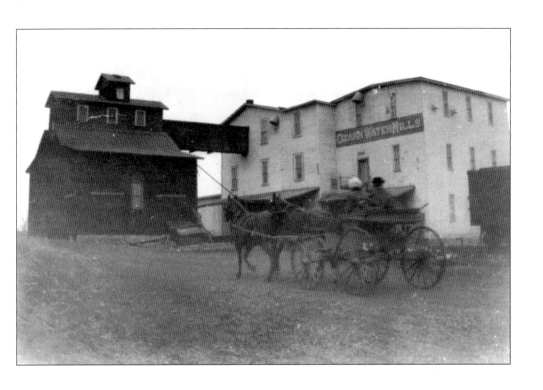

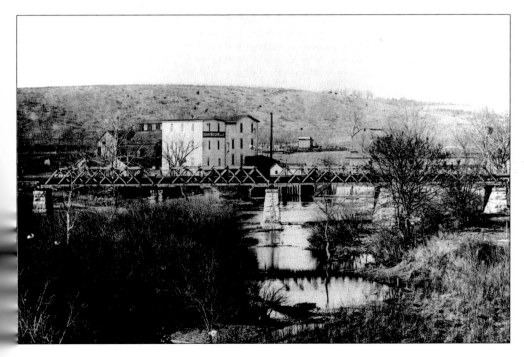

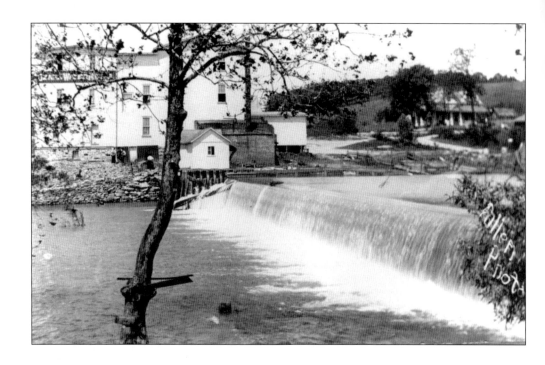

The above photo is another view of the Ozark Water Mills. The photo below shows the Ozark Water Mills after it burned down in about 1917. The long brown tank located in the back was where the ice factory of the mill made the ice.

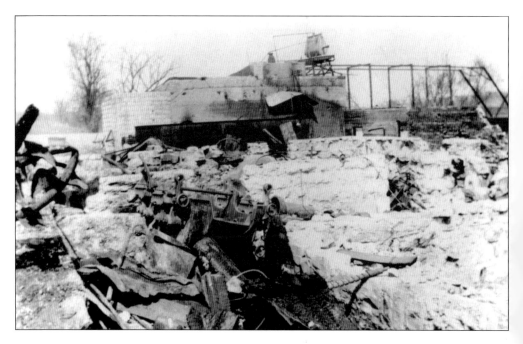

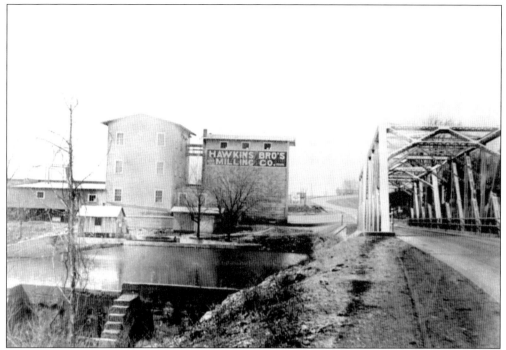

The Hawkins Bro's Milling Co., seen here in April 1927, is now owned by Johnny Morris of the famous Bass Pro Shop in Springfield, Missouri. This mill is still standing today with the bridge crossing over the Finley River.

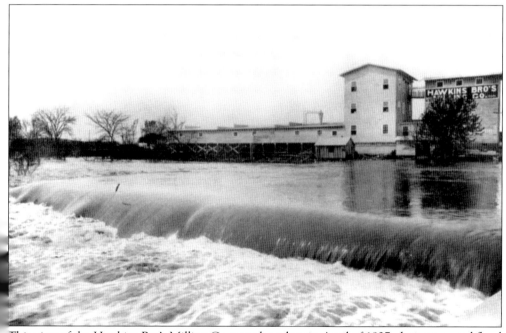

This view of the Hawkins Bro's Milling Co. was also taken in April of 1927, during a record flood for Ozark. Later, in January 1939, the mill caught fire and burned, but was restored soon after.

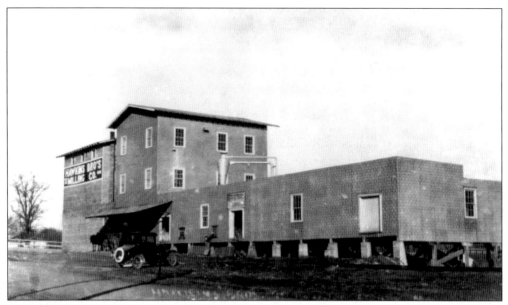

A third view of the Hawkins Bro's Milling Co. in Ozark is pictured from a different angle.

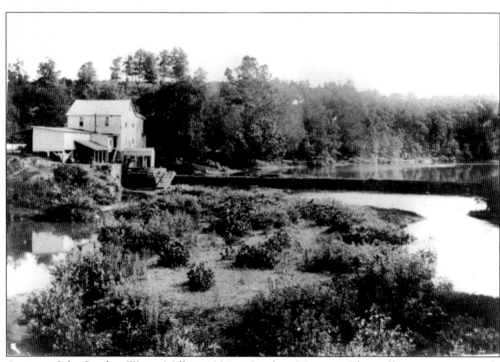

A view of the Linden Water Mill in 1921 at Linden, Missouri. The mill ran on a one-cycle engine at 25 horsepower. The Linden Water Mill was first established in 1905.

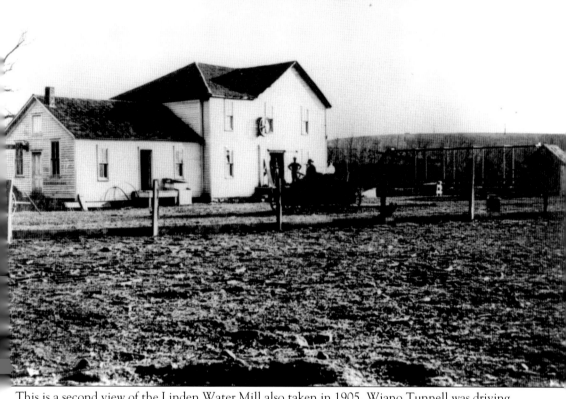

This is a second view of the Linden Water Mill also taken in 1905. Wiano Tunnell was driving the car, while A.M. Hawkins stands with his hands on his hips.

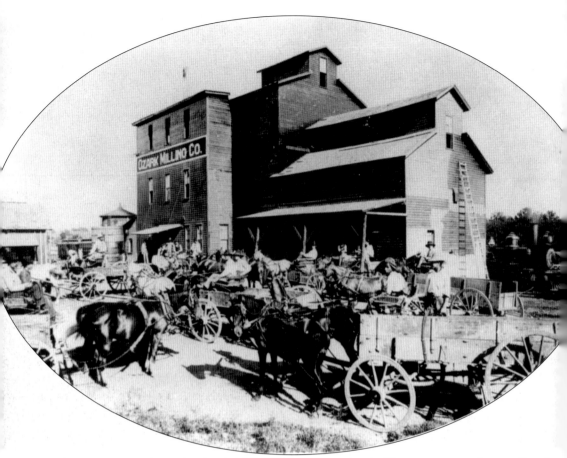

This 1904 image shows the Ozark Milling Company at Ozark. This was a steam flour mill and was established by W.L. Duncan at the Frisco Switch.

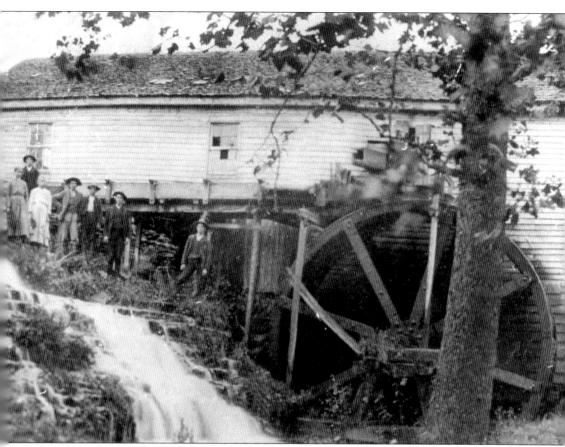

This was taken at Parch Corn Hollow located between Ozark and Linden. This land was settled by David Walker, who opened a grist mill in 1845 that was known as the Walker Mill. Prior to the establishment of this mill, there was a Carding Mill located here.

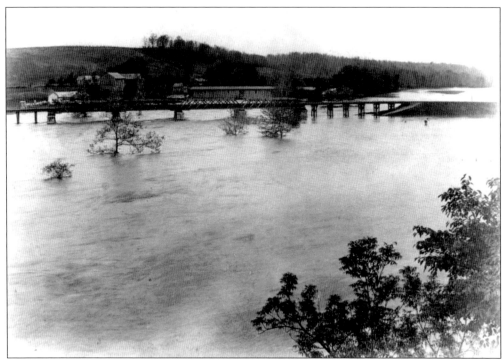

The Lawing Mill flood was captured in this photograph taken by William F. Simes on May 5, 1893.

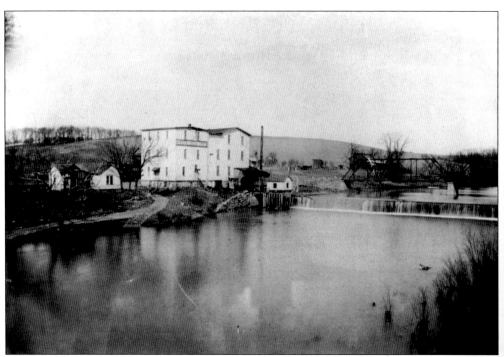

The Ozark Water Mill is shown in its picturesque setting along the Finley River.

Four
THE RAILROAD

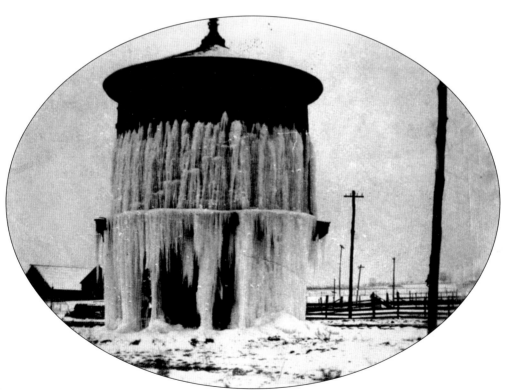

This water tank is the Frisco Water Tank. Due to continuously overflowing water, the water on the outside of the tank would freeze during the winter months. This caused difficulty for the hog cars as they were washed out frequently. Also, the pipes that ran under the water tank were connected to the same underground pipes at Garrison Springs, where the water came from.

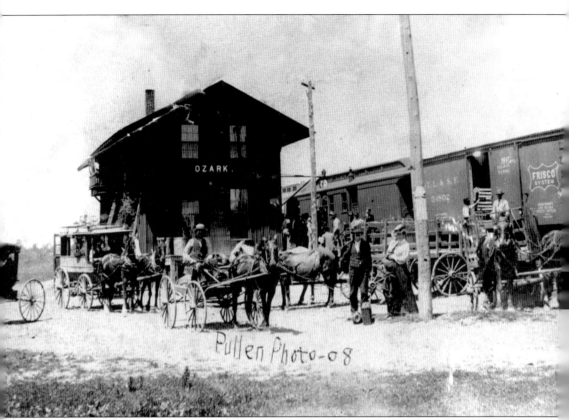

The Frisco Depot located on the west side of town is seen here in 1908. Bud Rose is in the mail cart. He carried the mail between the depot and the post office. Shorty Brown drove the "passenger bus" with a team of horses, carrying passengers from this depot into town. The wagon bus is on the left. The train had traveled from Springfield to Chadwick and back on a daily run. The train was a one-passenger coach and hauled such things as livestock, railroad ties, fruit, milk, and lumber.

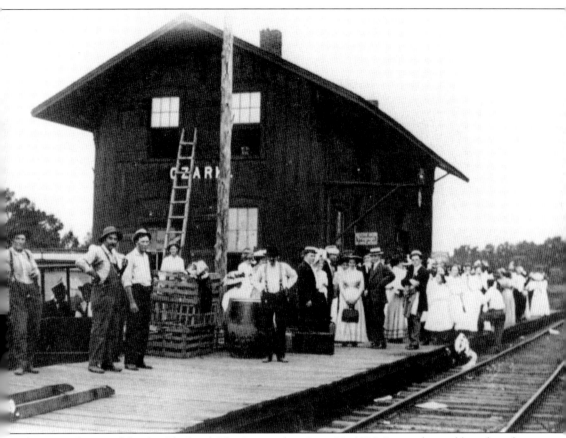

These people waited for the Chadwick Flyer's arrival on June 30, 1909. It was the wedding day of Miss Linnie Robertson to Mr. Howe Steele. This was a popular vehicle honeymoon of that era. It was called the Chadwick Flyer because, "When the people would see wild game, they would yell, 'Stop the train,' wherever they where," said Ruth Scott of the Christian County Historical Society.

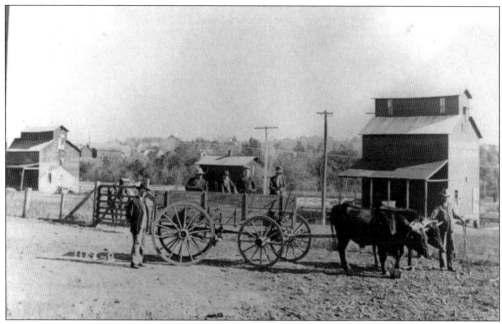

This was the Grain Elevator that was north of the Frisco Depot. It was the original Frisco Station, which was enlarged later. The man standing on the left side of photo was R.C. Kissee.

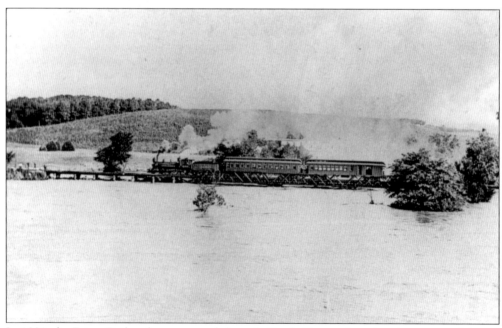

In 1881, the Frisco Railroad came to and through Ozark. Due to the rains that occurred during the spring, the Finley River often surpassed flood stage.

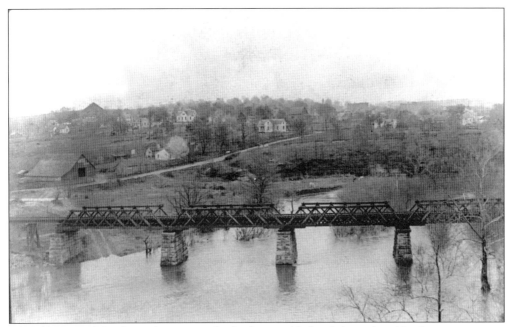

The old town of Ozark can be seen in the background behind the railroad bridge.

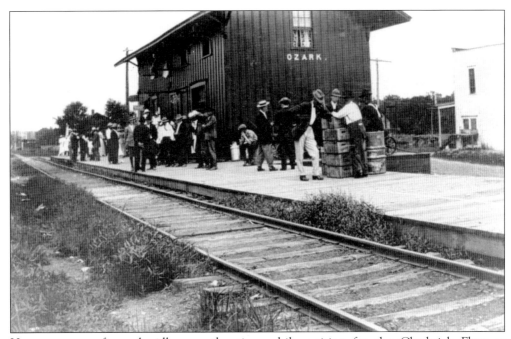

Here a group of people idly pass the time while waiting for the Chadwick Flyer at the Ozark railroad station.

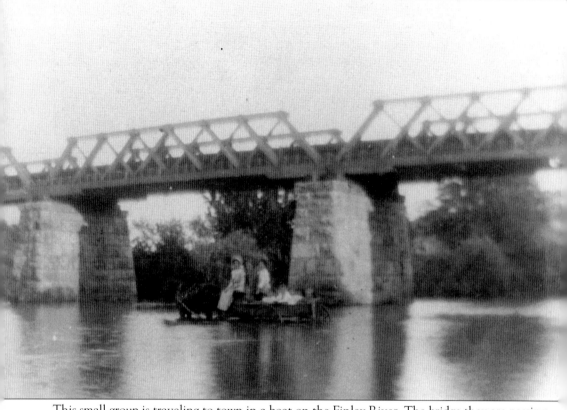

This small group is traveling to town in a boat on the Finley River. The bridge they are passing under is the railroad bridge at Ozark. A piece of this railroad's trusses was taken by Don Russell, who had built the Kingsway Church in Springfield.

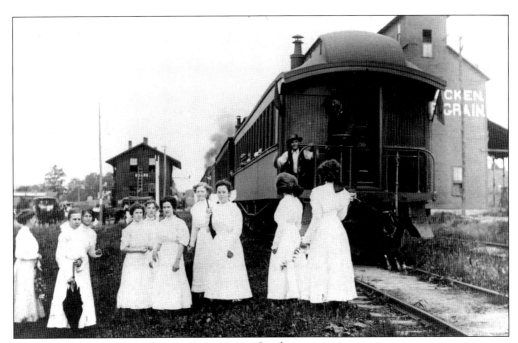

A group of women await the arriving train in Ozark.

Just left of the old water tower was a "section house." The section house was living quarters for only men. Bill Taylor is the man straddling the railroad tracks.

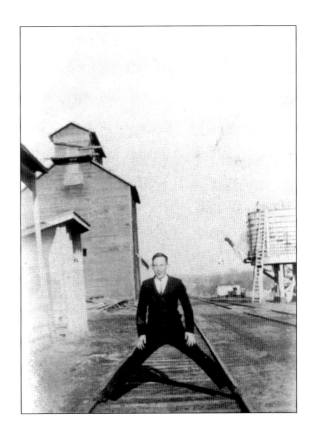

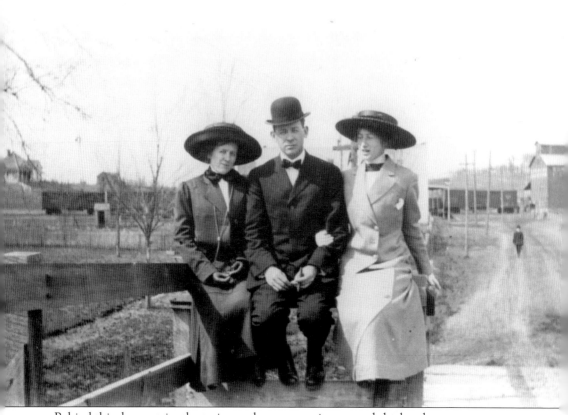

Behind this dapper trio, the train can be seen coming around the bend.

Five

EARLY CHURCHES AND THE OLD SCHOOL

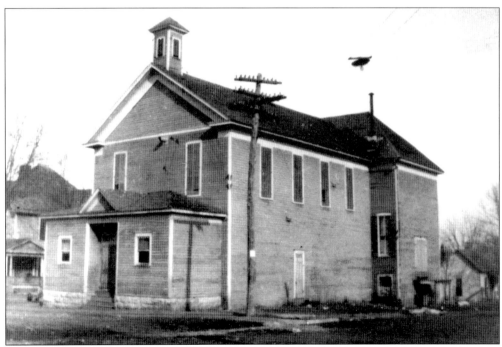

This church was originally built as the First Baptist Church. The Methodists and Christian Disciples also used it, and the Masons used the upstairs.

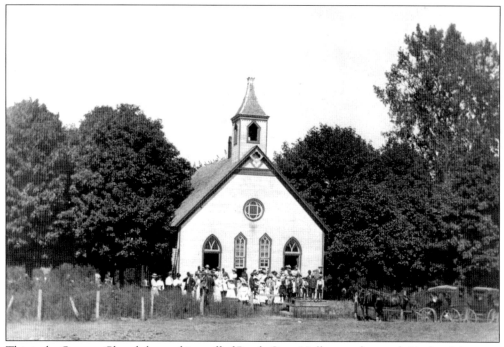

This is the Smerna Church located just off of Parch Corn Hollow road towards Linden, Missouri.

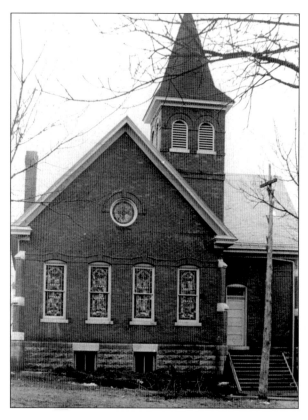

This was the Methodist and Presbyterian Church, which is now occupied by the Christian County Historical Society in Ozark. The photo was taken in about 1913.

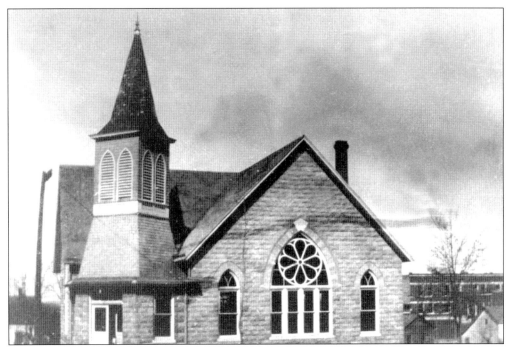

This church was originally known as the Ozark Presbyterian Church. But it was sometimes referred to as the A.T. Yoakum Church, since she gave so much money to the church.

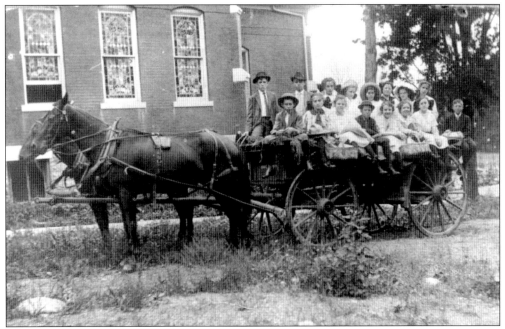

A wagon of people outside the Methodist and Presbyterian Church. This church building was used by the Presbyterians as a mortuary. The wagon driver was Bill Woody. This photo was taken in the late spring or summer of 1913.

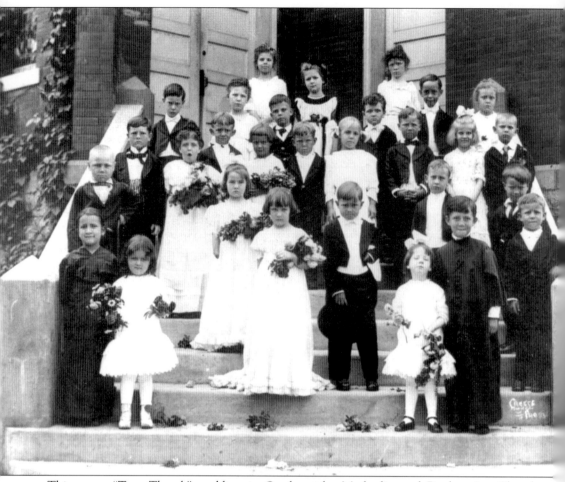

This was a "Tom Thumb" wedding in Ozark at the Methodist and Presbyterian Church. Presently, this building houses the Christian County Historical Society. Pictured are, from left to right: (top row) Alta Hartley, Lois Hunter, and Clista Webber; (second row down) Howard Braeazeale, Eula Daugherty, Robert Logan, Max Robertson, Violet Hicks, and James Wallace; (third row down) Howard Rogers, Reba Forrester, Kyle Keltner, Cleo Garrison, Eugen Bronson, Helen Kissock, Clell Bain, Ruth Webb, and Christopher Wolf; (fourth row down) Roger Delman, Mildred Melton, Bill Taylor, and Newton Turner; (fifth row down) Girl unknown, Mary E. Shallenbere (Shubert), Christine Giehl, Ward Crain, Jennie Taylor, Allen Walker, and Harold Brownfield. The bride and groom are Christine Giehl and Ward Crain.

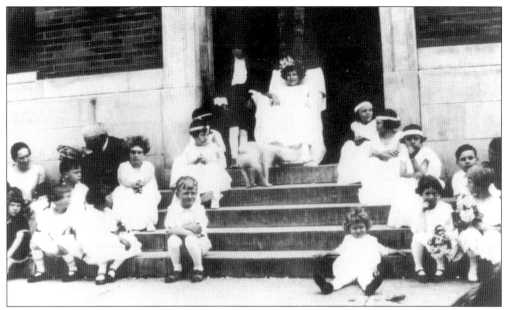

Another "Tom Thumb" wedding held at the Methodist and Presbyterian Church; the bride and groom are sitting at the top of the steps.

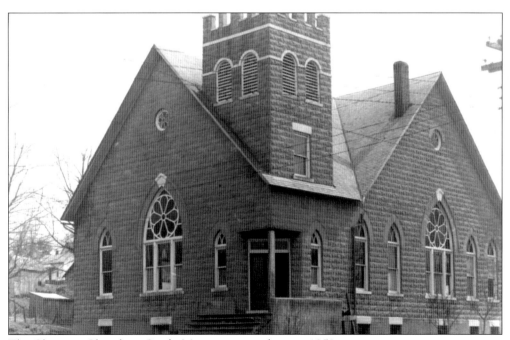

The Christian Church in Ozark, Missouri is seen here in 1959.

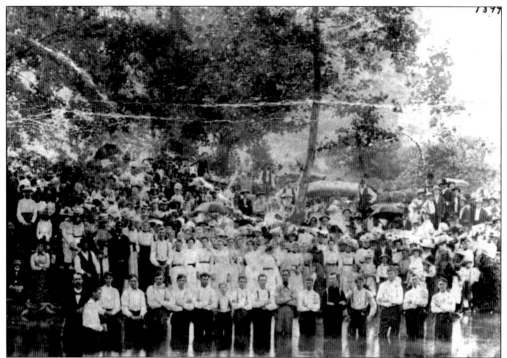

This baptism took place at the Finley River. It was just at the base of Eutsler Hill in 1899, near Ozark.

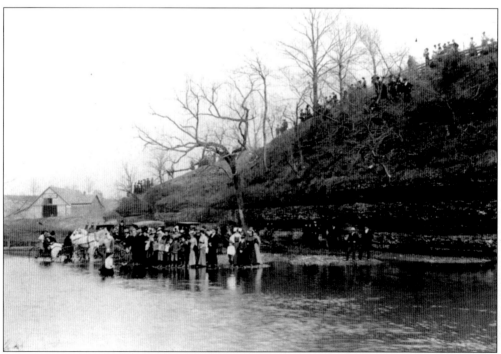

This baptism took place in the Finley River as well at the Blue Hole by the Bluff Spring outlet not far from Ozark.

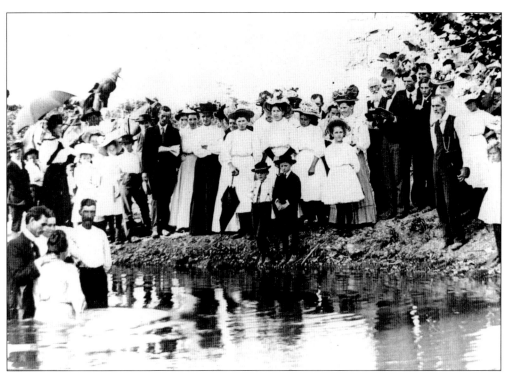

The Reverend J.L. Henry gave Ethel and Elbert Hendricks a baptism on their wedding day in 1908.

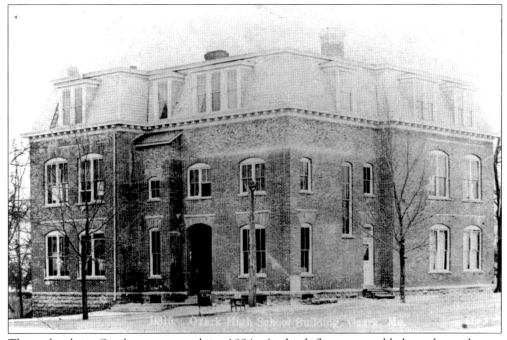

This school in Ozark was erected in 1894. A third floor was added on later. It was torn down in 1923.

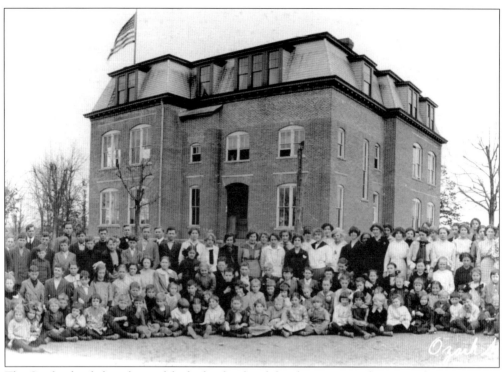
The Ozark school class photo of the high school and the elementary students on February 9, 1914.

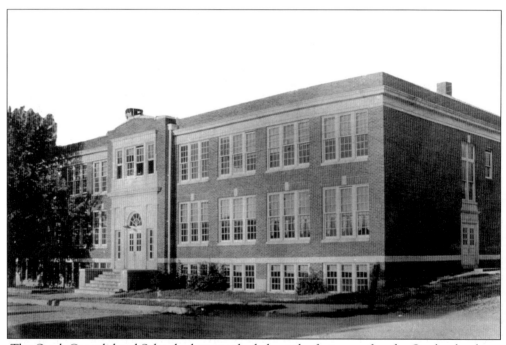
The Ozark Consolidated School, photographed about the first year after the Ozark school was consolidated. In 1922–1923 the new High School was built in front of the old school location.

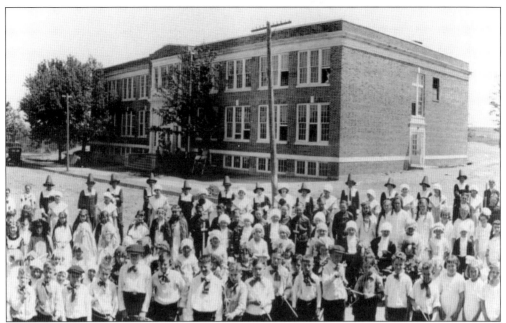

The students of the new school are seen here in front of their school in May of either 1922 or 1923. In 1941, a grade school and gym were added.

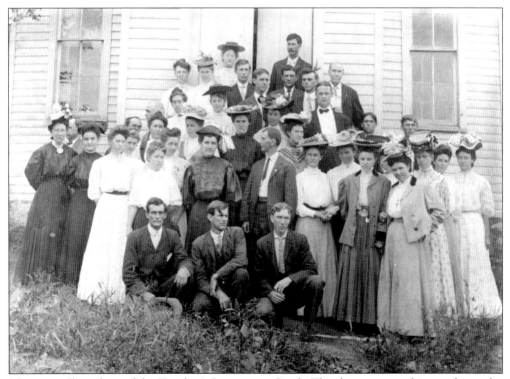

These are all teachers of the Teacher's Institute in Ozark. The three men in the very front who are kneeling are, from left to right, W.C. West, Professor; Tom Mapes, Instructor; and Joel Shadoin, Superintendent of Schools.

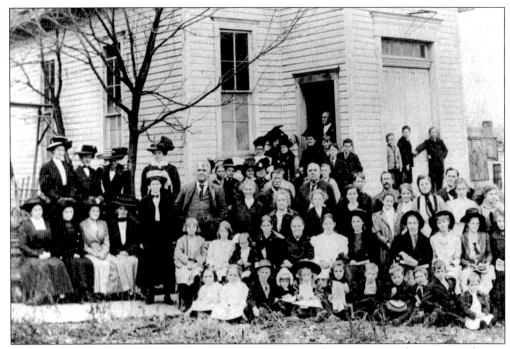

Here is a second view of the Teacher's Institute in Ozark, Missouri with a group of men, women, and children.

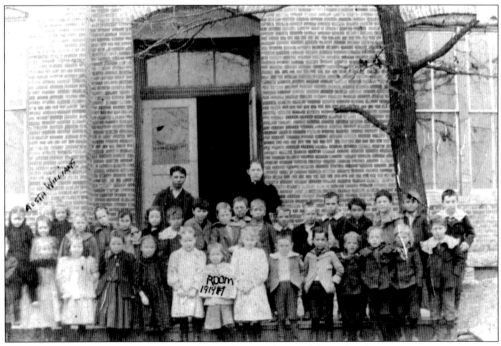

This is the first grade class from Ozark standing in front of the school in 1917.

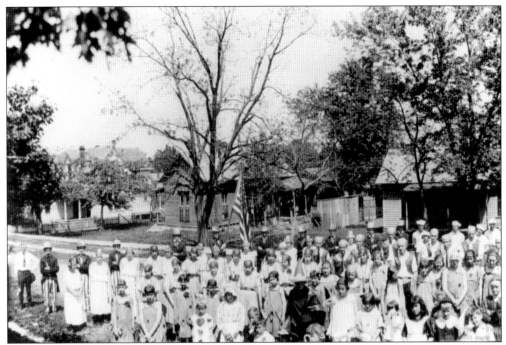

The house on the far left behind the group of students is possibly where the present day Health Department is. This photo was probably taken in May of 1922.

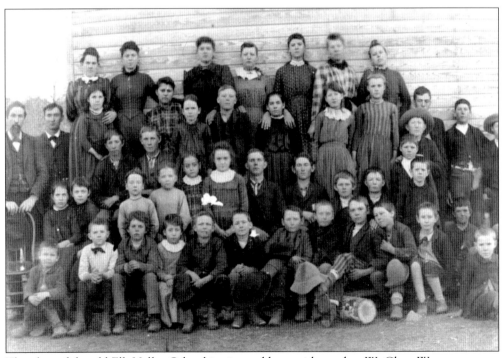

The class of the old Elk Valley School is pictured here with teacher W. Clare West.

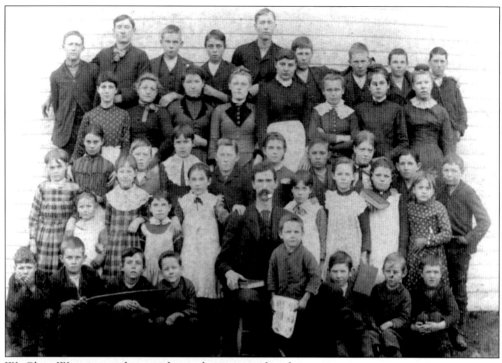

W. Clare West is seen here with another group of students.

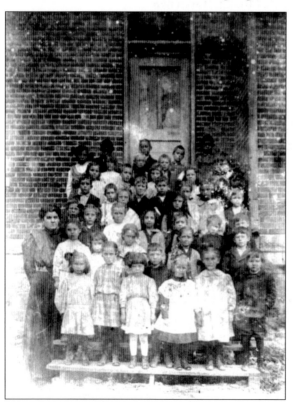

This was the elementary class at the Ozark School.

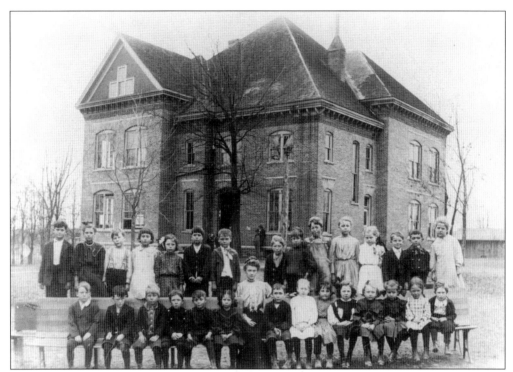

The 1911 class of the Ozark School in Ozark, Missouri is seen here.

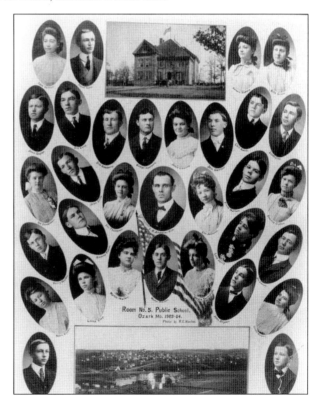

This is the Room No. 5 high school class picture for 1903–1904.

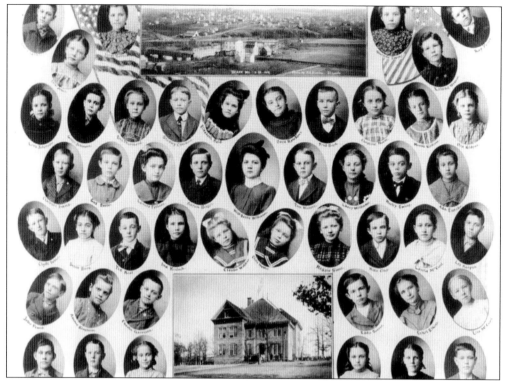

This is another class photo of elementary students in 1903–1904, also with a picture of an overview of Ozark and the school. This class was in Room No. 4.

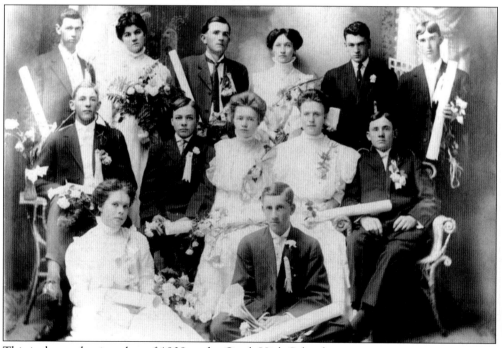

This is the graduating class of 1908 at the Ozark High School.

Six
ASSOCIATIONS

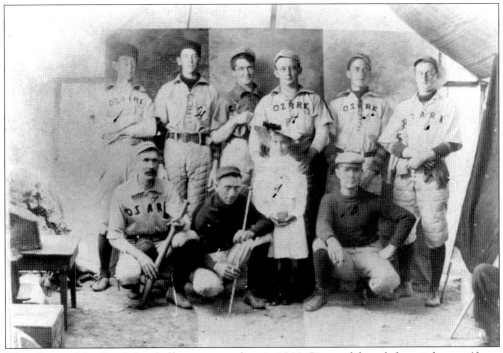

This photo of the Ozark baseball team was taken in 1902. Pictured from left to right are: (front row) Jason F. Adams, John Crain, Lucile Adams, and George Howard; (back row) H.B. Johnson, Rosco Wolf, Ad Williams, Harry Johnson, Guy Logan, and ? Miller.

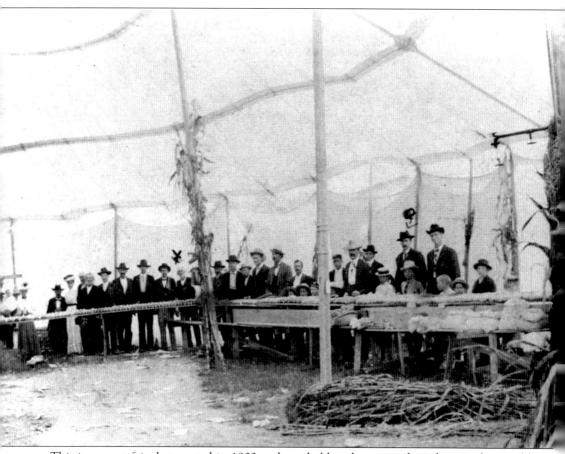

This is a street fair that started in 1903 and was held each year to show fruits and vegetables, both fresh and canned. Some of the other things shown at this street fair were hand work items. This man with the letter "o" above his head was Jake Hartley. The man with the letter "x" above his head was William Easson.

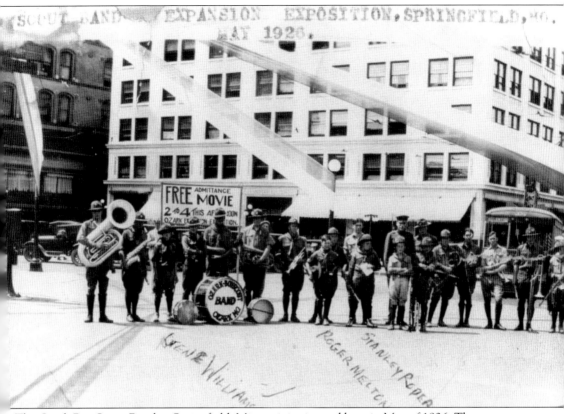

The Ozark Boy Scout Band in Springfield, Missouri, is pictured here in May of 1926. The owner of this photo said, "This was part of one of largest assemblies of a regional band."

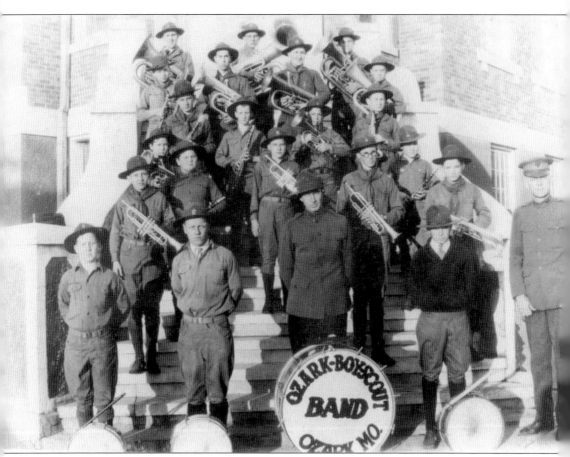

Here is another photo of one of the Ozark Boy Scout Bands. From left to right are: (front row) three unidentified, Johnny Pyle, and unidentified; (second row) Joe Brown, ? Roper, Norman Baxton, unidentified, and Linde Deliel; (third row) Richard Schoellenburger, two unidentified, and Wallace Pyle; (fourth row) Jack Farthing, and three unidentified; (fifth row) Malcolm Logan, Howard Brazel, and ? Brown; (sixth row) all unknown.

This was one of the advertisement curtains that was located in front of the stage at the Opera House, also known as the Club Theater.

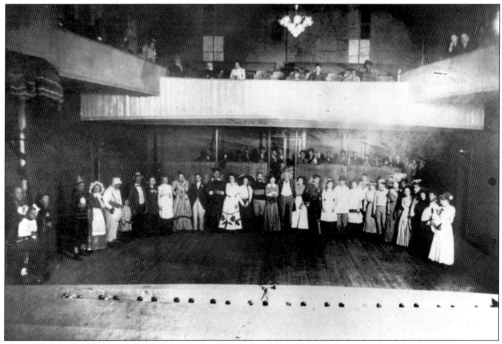

This building was originally built by the First Baptist Church then later became known as the Ozark Opera House-Club Theater. All of the important events that occurred in Ozark took place here, whether school plays or other associations and activities. It was located on the northwest side of the Square and on the corner of East Church Street and Fourth Avenue.

This is a photo of the old "Booster Club Park," which is now the Ozark Park located in Ozark.

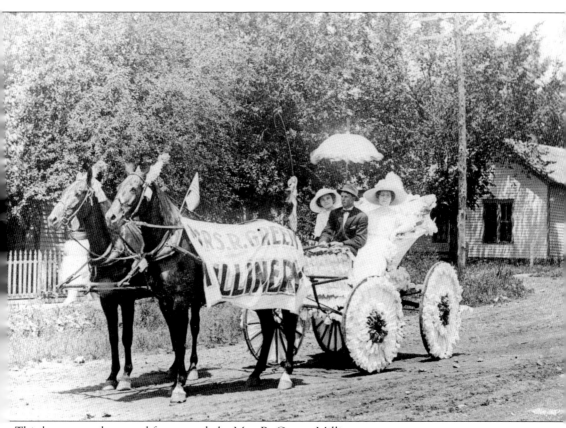

This buggy was decorated for a parade by Mrs. R. Green, Millinery.

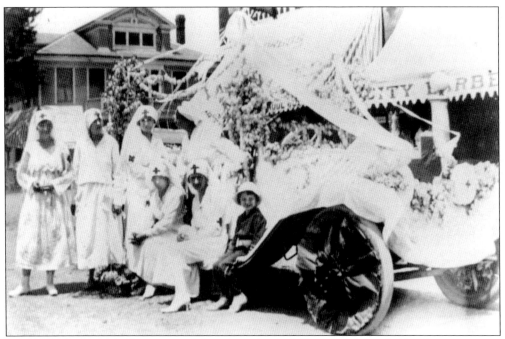

The group and parade float is possibility from the Red Cross. The Smith Hotel is again seen in the background.

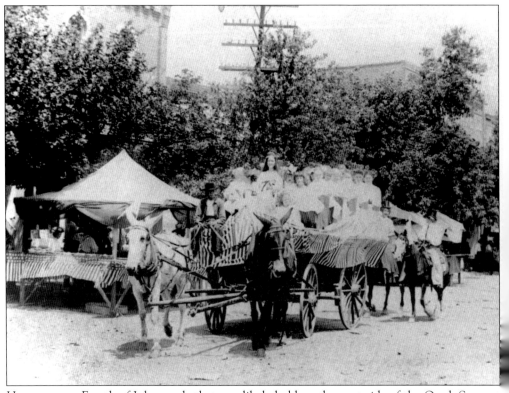

Here we see a Fourth of July parade that was likely held on the west side of the Ozark Square.

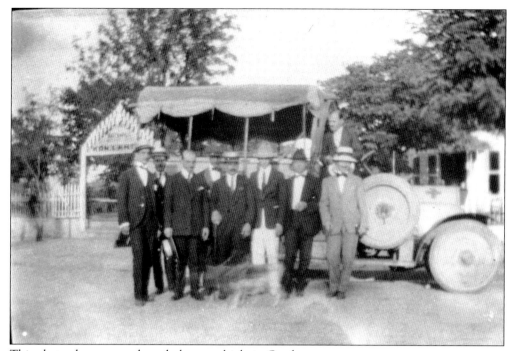

This photo shows an early ambulance vehicle in Ozark.

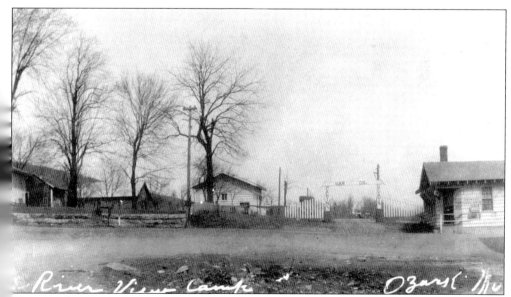

This was the River View Camp in Ozark. It was located just north of the Ozark Mill, across he street.

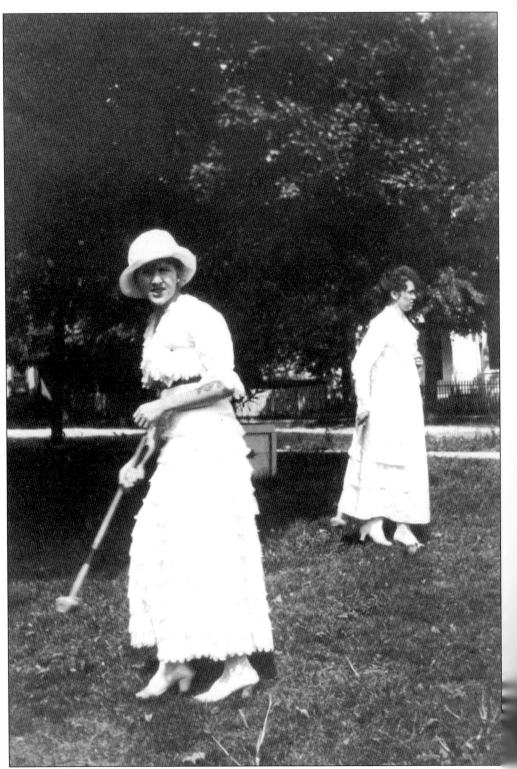

Croquet was a game played on a nice day for fun, and was common in Ozark.

Seven

Springs and Caves

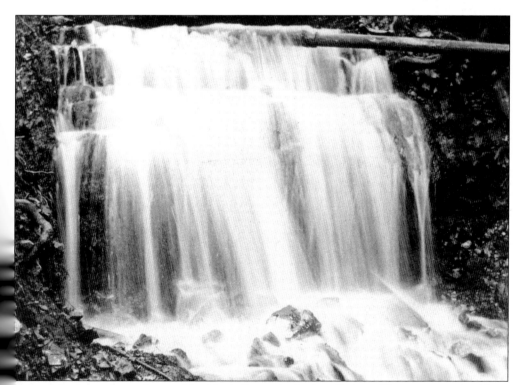

Located just one mile northeast of the Ozark Square is Garrison Springs. The water was piped from this spring to the Frisco Station and Martha Garrison was paid one hundred dollars a year for the water. Many people would drive to this spring just to haul the water to their homes and farms.

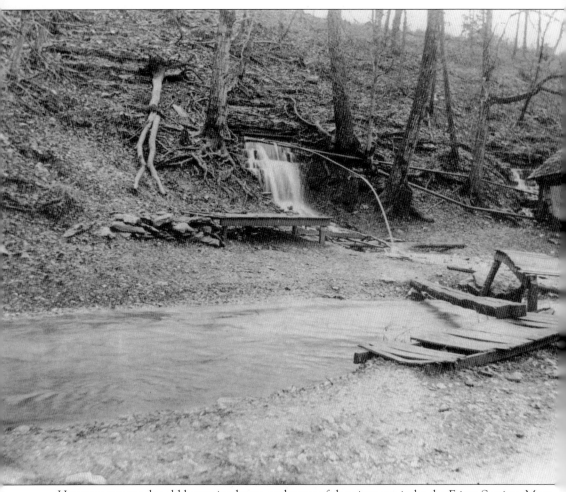

Here you can see the old log spring house and some of the pipes put in by the Frisco Station. Most of the pipes were put underground. The water went to the Frisco Water Tower. The pipe in front was the pipe that people used to fill their barrels, which they hauled to their homes and farms.

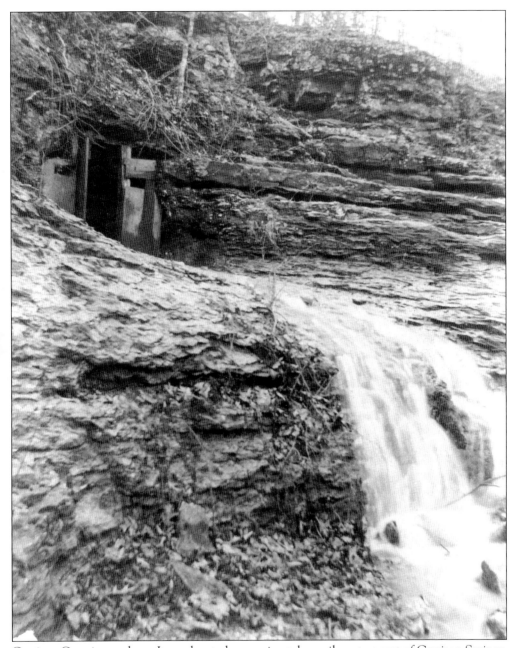

Garrison Cave is seen here. It was located approximately a mile or two east of Garrison Springs. On Sundays many young couples took walks to this cave. It had a small lake inside, but water didn't often run out of it. Surrounding neighbors kept their potatoes and other vegetables up on a dirt shelf in this cave.

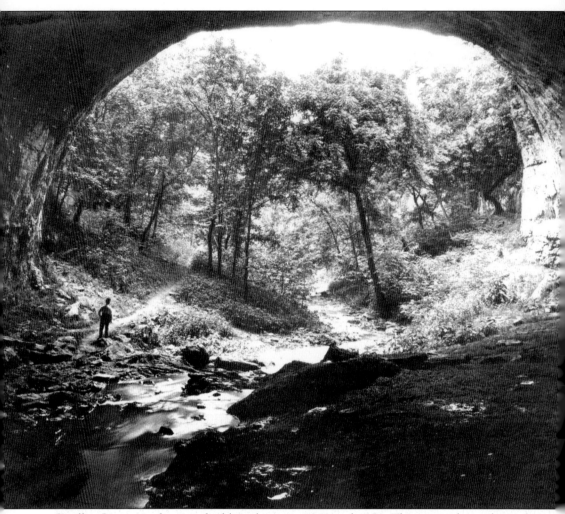

Smallin Cave was photographed here between 1940 and 1950. The cave is located just three miles north of Ozark. Some believe this cave was used in the Civil War. This was also the cave that the American Explorer Henry R. Schoolcraft discovered in 1819. The entrance height is approximately 125 feet.

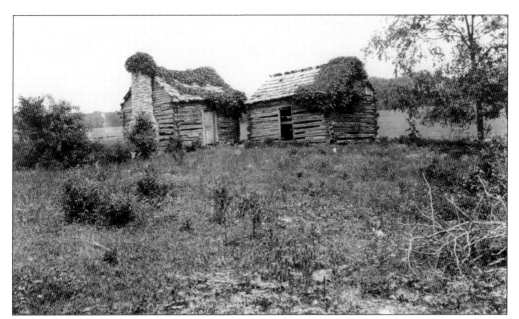

This log cabin was located above the Garrison Cave in Ozark.

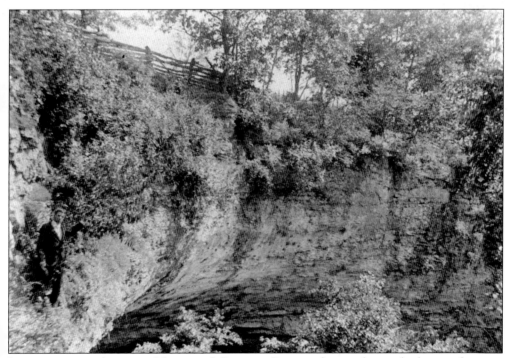

It is easy to see the natural beauty of Garrison Cave, and to understand why people enjoy exploring the area.

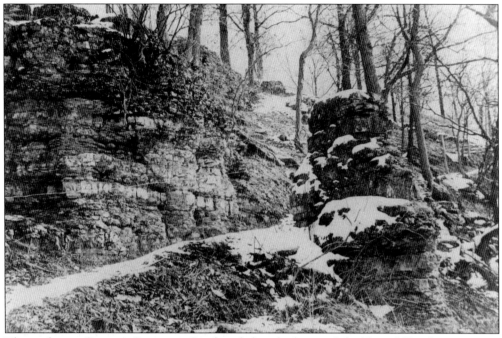

This path is at Garrison Springs in Ozark; it led to the home of the Tunnel Family.

Garrison Springs also showcases the natural beauty of the area.

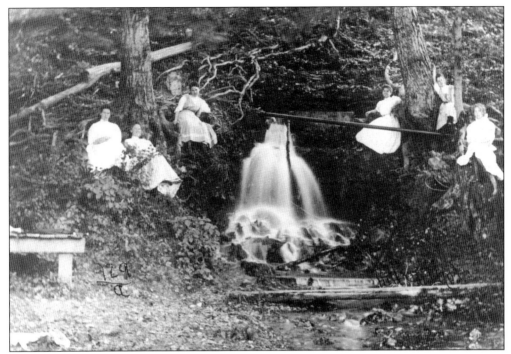

A group of people is seated around the spring at Garrison Springs in Ozark, enjoying nature.

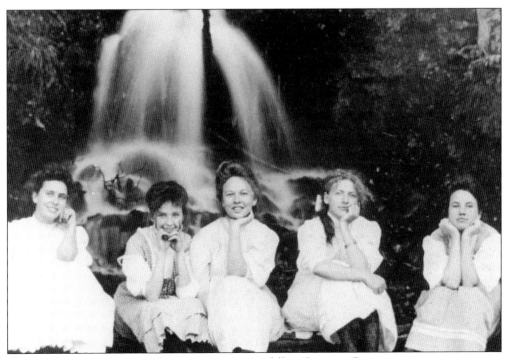

This group poses in front of the picturesque waterfall at Garrison Springs.

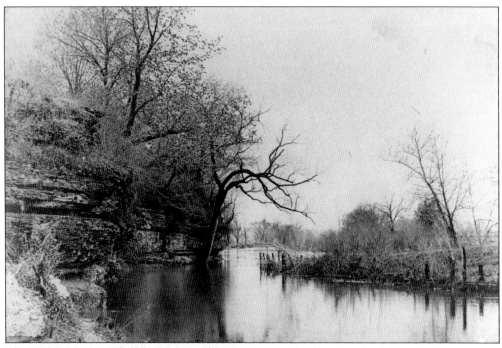

The Finley River at Bluff Spring, seen here, was a popular location for fishing.

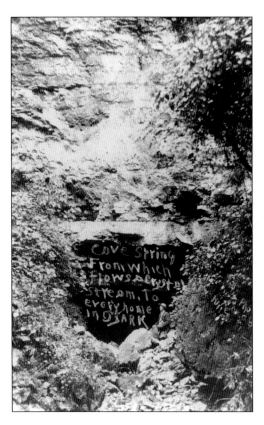

This is Cove Spring, whose waters flowed into every home in Ozark, according to the sign.

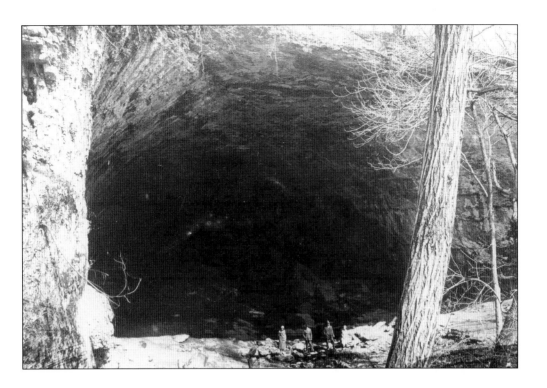

Pictured on this page and the next, the entrance to Smallin Cave invites visitors to enter and explore.

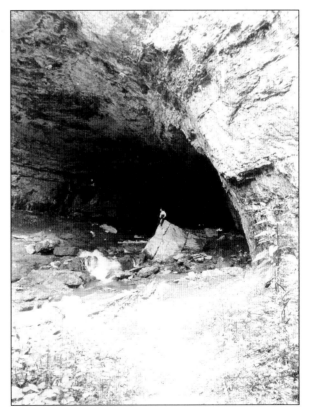

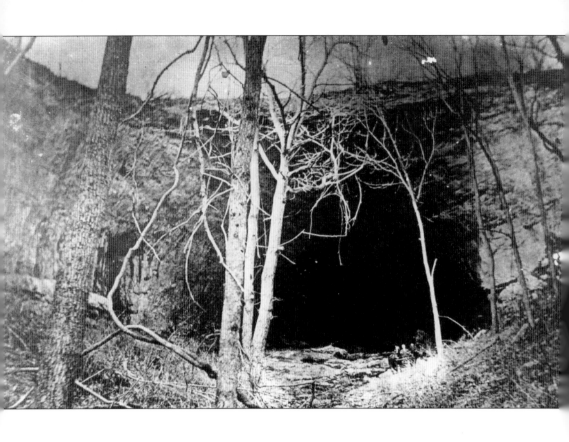

Eight

FINLEY RIVER

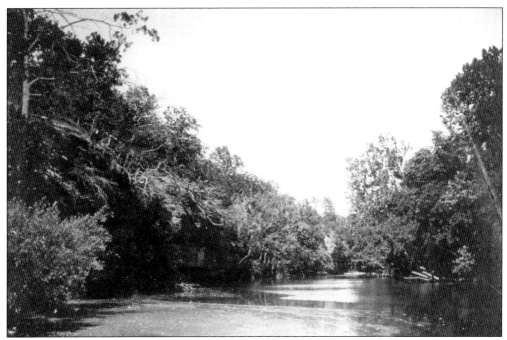

Taken in 1900, this photograph of Finley River showcases the great natural beauty of the Ozark area.

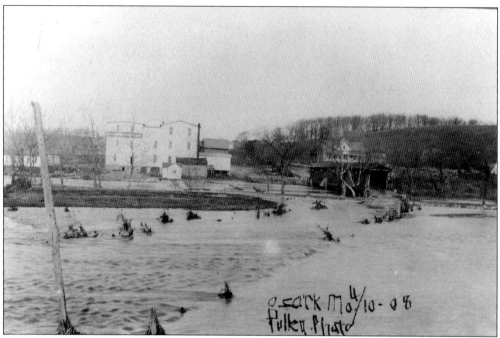

This photo of a flood on Finley River was taken on April 10, 1908. Another flood occurred soon after, on May 17, 1908. There were three spring floods that year.

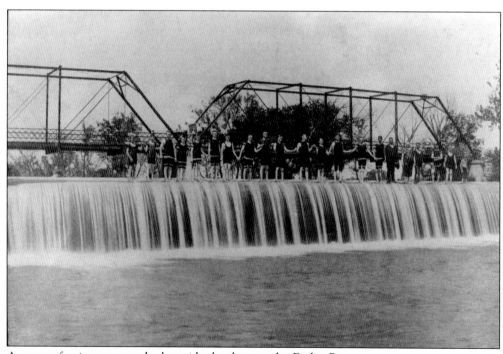

A group of swimmers stands alongside the dam on the Finley River.

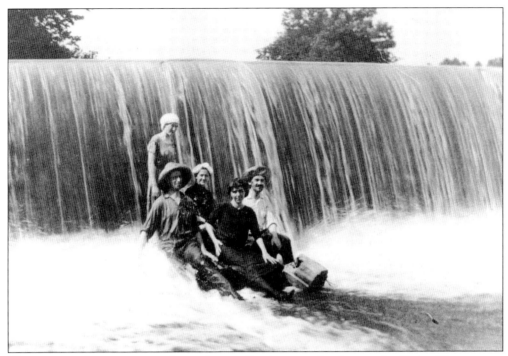

These men and women enjoy the cool water flowing over the dam on the Finley River.

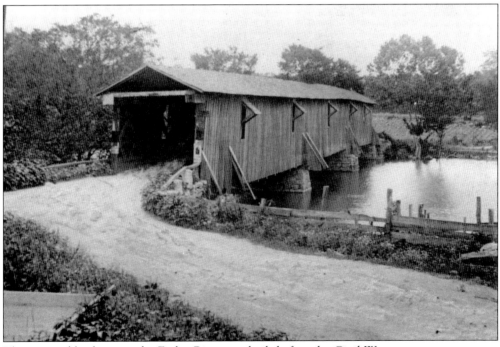

This covered bridge over the Finley River was built before the Civil War.

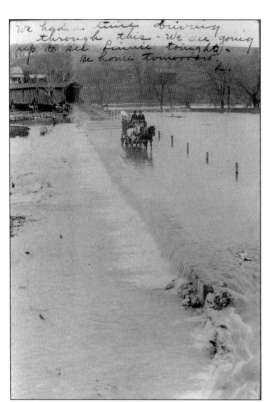

We had a time driving through this. We are going up to see Finnie tonight. Be home tomorrow. Z.

This road had led to the old covered bridge and mill. The covered bridge seen here has since been washed away.

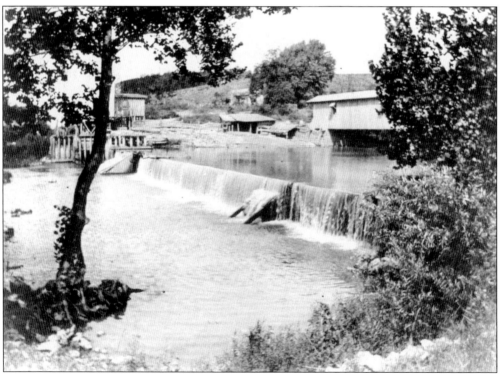

The old covered bridge spans the Finley River just above the dam.

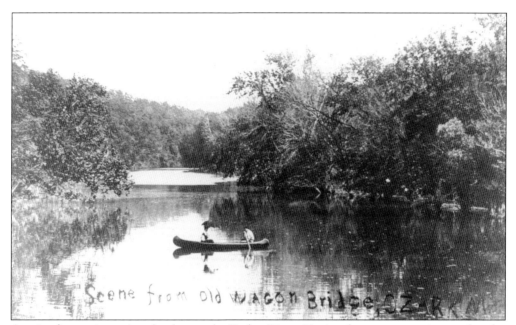

A pair of canoeists enjoy the day on the Finley River. Notice the woman staying cool under her parasol.

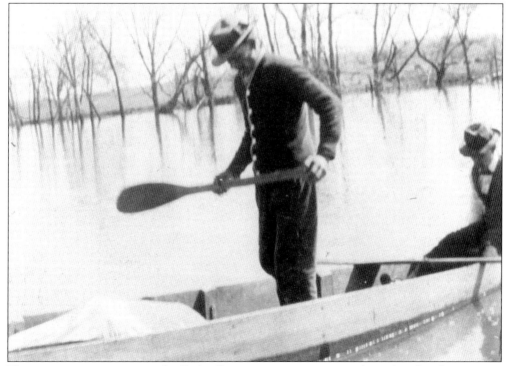

These two men canoeing on the Finley River seem very intent on the task at hand.

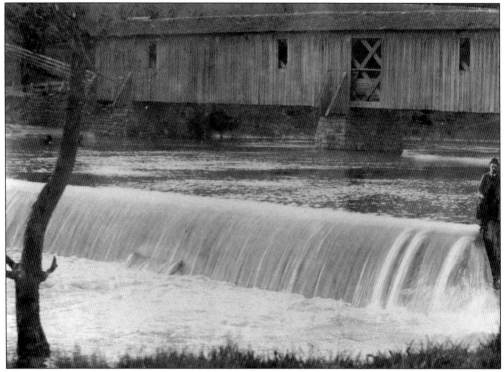

This is a closer view of the old covered bridge before it was washed away.

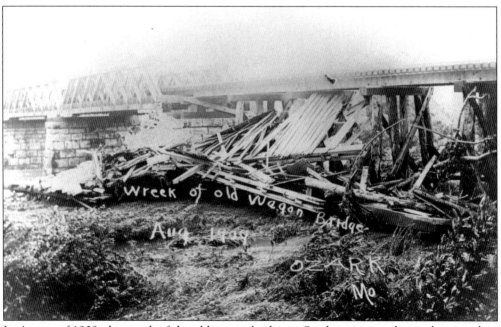

In August of 1909, the wreck of the old wagon bridge in Ozark is preserved in a photograph.

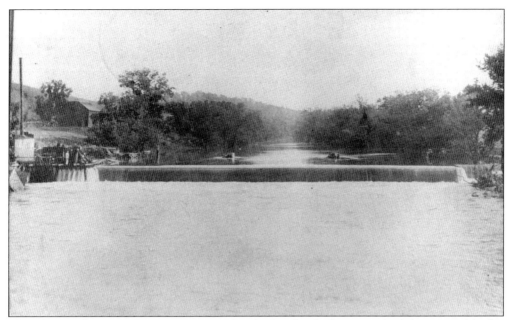

This photo, taken on July 16, 1909, was after the big flood of 1909 washed the covered bridge away, greatly changing the look of the river.

This spot on the river near Bluff Spring was another popular fishing hole.

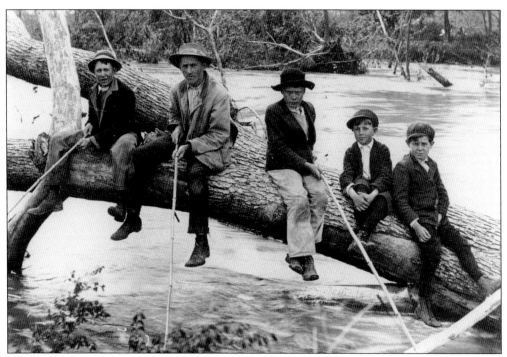

This fallen tree makes a perfect fishing perch for this man and four boys, whose identity is unknown.

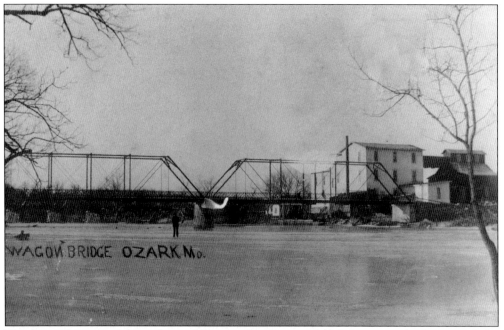

The horse-drawn wagon in the middle was the "Frisco Hack." It met with the train daily. Charles Hunter was the driver of the delivery hack and most had known him from his grocery store. The bridge itself was a new bridge at the time.

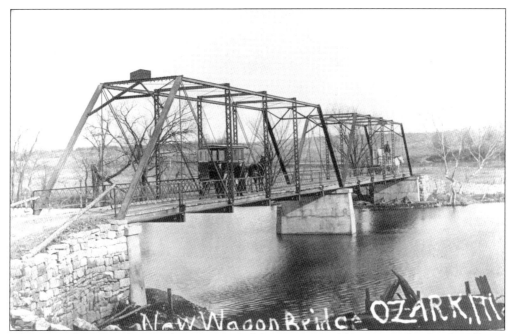

The Riverside Inn Bridge seen here was moved from its original location at the Ozark Mill site.

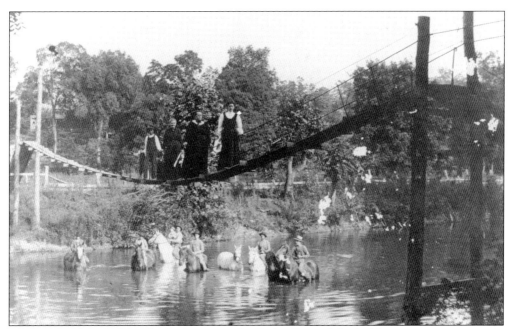

This is one of the old foot bridges crossing the Finley River. It looks like a precarious crossing, and the men on horses in the river seem almost poised to rescue anyone who might fall.

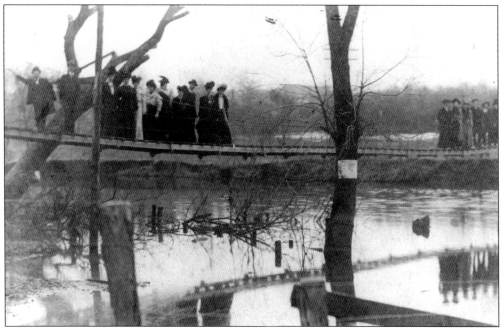

In 1902, the swinging bridge in Ozark crossed over the Finley River, directly south of the depot, where in 1959 the cheese company plant was located.

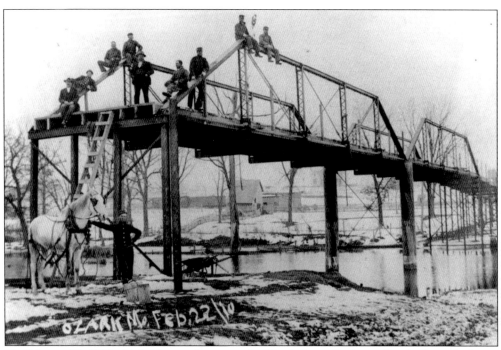

On February 22, 1910, this bridge was known as the Tenth Street Bridge in Ozark. Since the lower part of this bridge needed to be repaired, the bridge was renovated with an asphalt floor addition.

Nine
SCENIC VIEWS

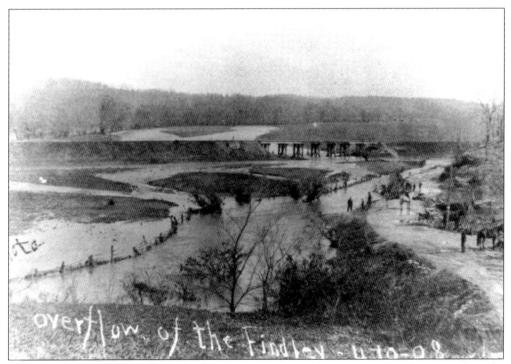

This April 10, 1908 photo shows Eutsler Hill as you looked down the road at the railroad trestle, close to where the edge of the city park was. The trestle was torn down after the rail service stopped at Chadwick.

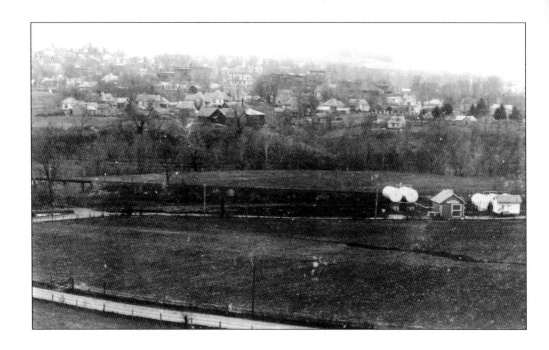

These panoramic photographs show the small town beauty of Ozark.

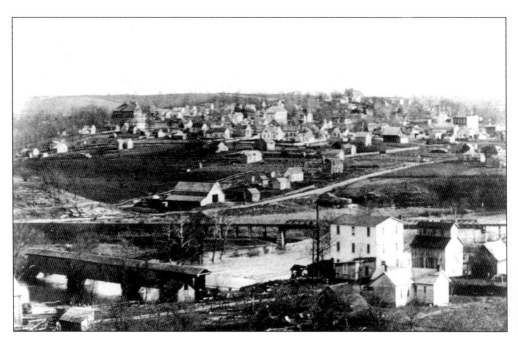

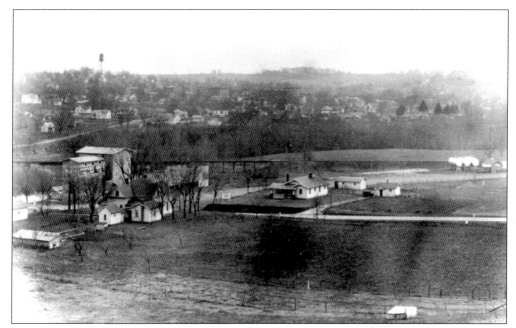

This image looks south towards Ozark; note the water tower on the left.

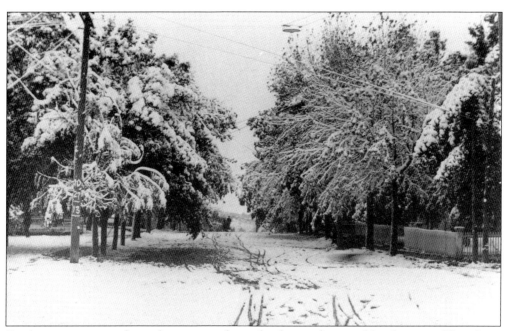

Ozark is a winter wonder with wagon trails on the dirt road covered by the snow. This photo was taken October 27, 1913.

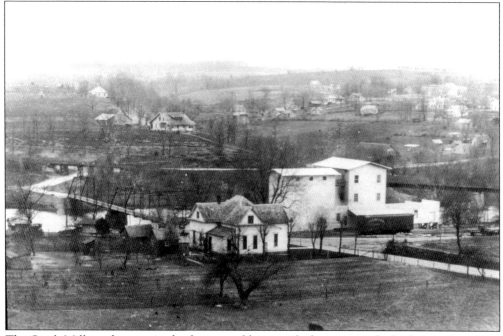

The Ozark Mill can be seen in the foreground here, with the town in the background, and the river winding its way on the left.

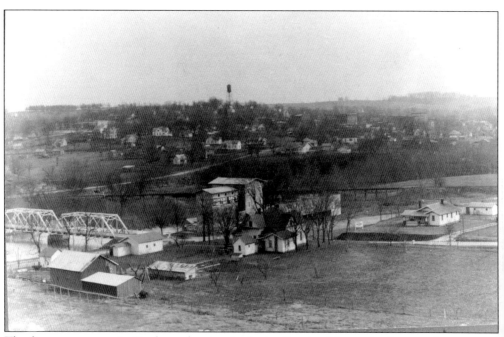

The first water tower in Ozark can be seen in the horizon in this scenic photograph.

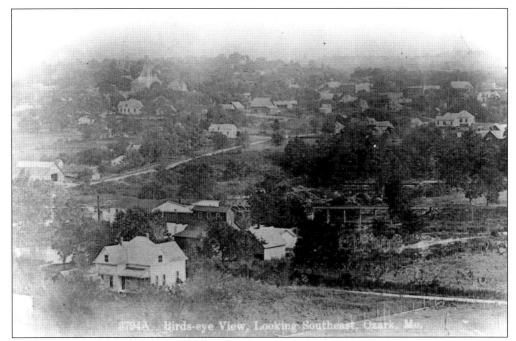

This is Ozark as seen on February 11, 1913.

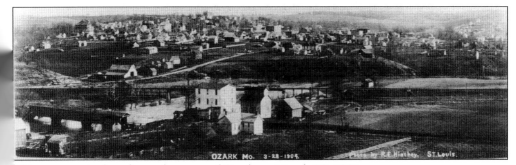

This panoramic shot shows the town of Ozark on March 28, 1904.

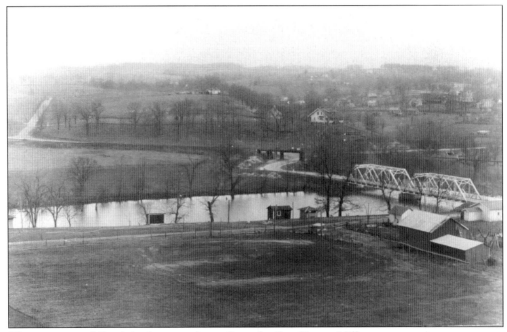

This is a view of Ozark looking southeast from the Ray Young Hill.

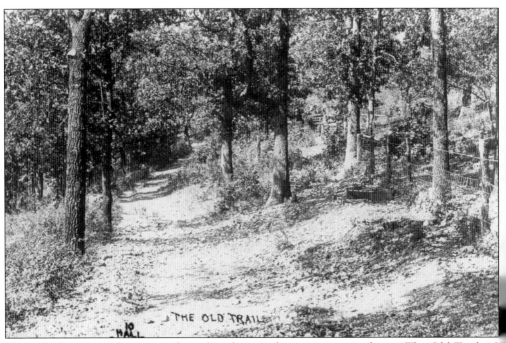

THE OLD TRAIL

The only thing to go by in regards to this photo is the writing on its front, "The Old Trail, 10 Hall Photo Co." This photo was taken around 1910.

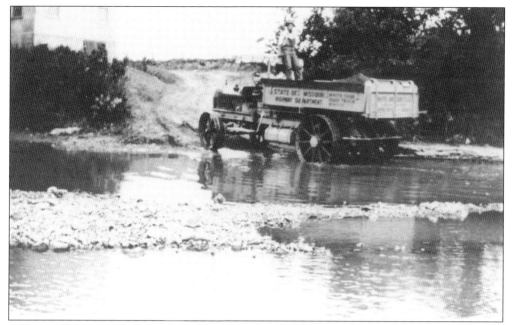

A State of Missouri Highway Department truck is crossing the Finley River without the help of a bridge.

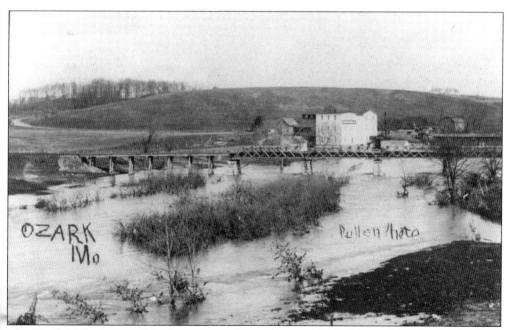

The Ozark Mill, river, and bridge are seen here. The river looks low, judging by the sandbars and islands popping up in the riverbed.

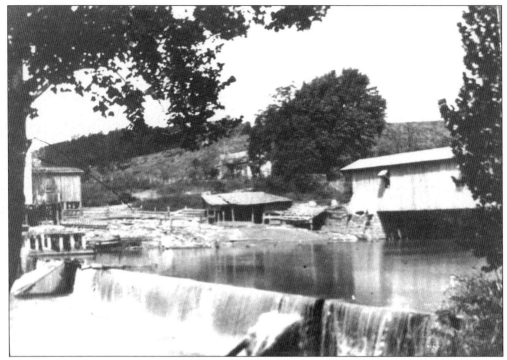

The number of surviving photos of the covered bridge over the Finley River reveal that it was a popular setting for taking pictures.

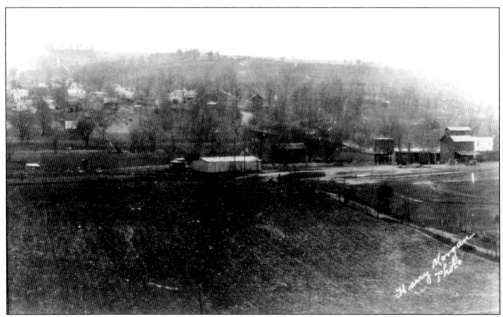

This old photograph shows the signs of age, but you can still see the burgeoning town of Ozark taking shape on the hillside.

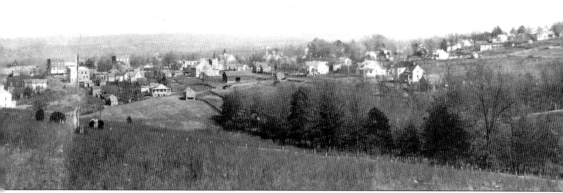

The city of Ozark is seen covering the hillside in this panoramic view.

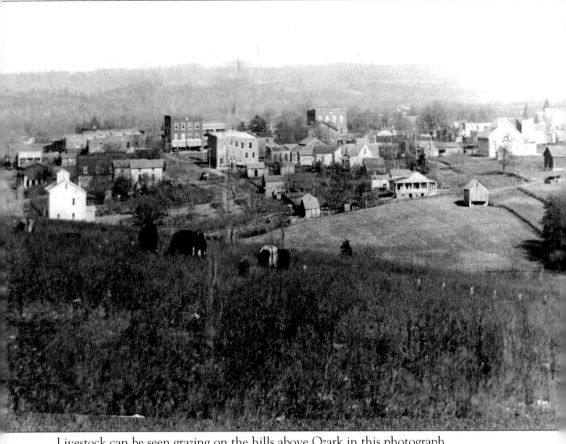

Livestock can be seen grazing on the hills above Ozark in this photograph.

Ten

PEOPLE IN OUR HISTORY

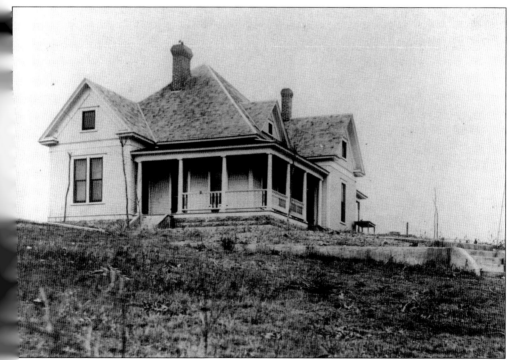

his was the home of the Rich Kissee family. It looked down over the grain elevator across the acks from the Frisco Station. In 1988, the home was across the street from Ozark High School.

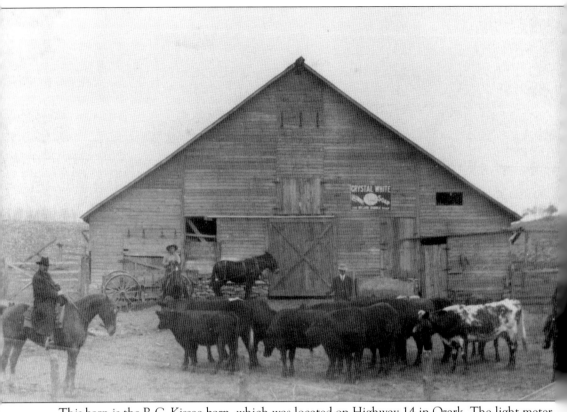

This barn is the R.C. Kissee barn, which was located on Highway 14 in Ozark. The light meter for both the house and barn was located inside this barn.

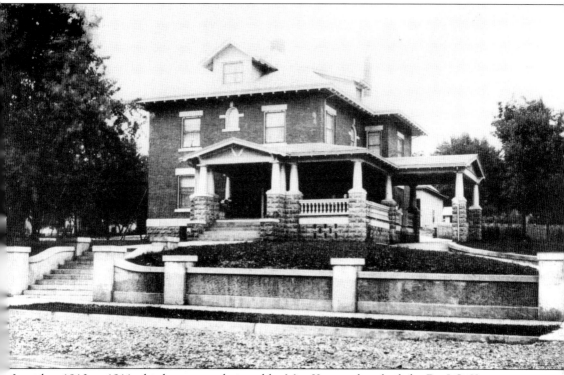

In either 1910 or 1911, this house was designed by Mrs. Young, then built by Dr. J.C. Young. It was on the corner of North Sixth Street and Church Street.

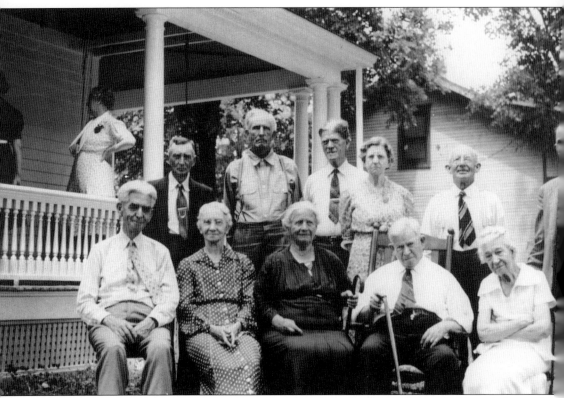

This photo, taken June 23, 1940, shows friends and family of John C. Rogers. From left to right are: (front row) John Robertson, Ivy Rogers, and three unidentified; (second row) John C. Rogers, Telia Williams, Luther Vaughan, and Mack Logan; (third row) both men unknown. The two women on the front porch are also unknown.

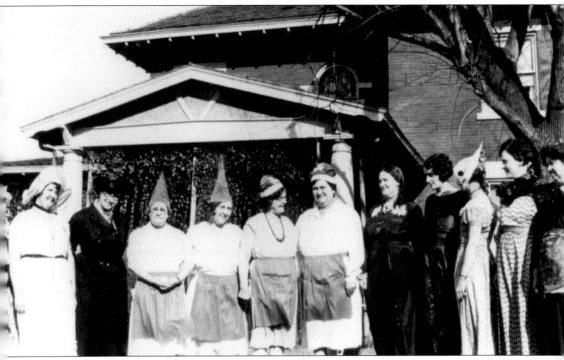

Here we have a group of women in front of the Youngs' home dressed up in costumes for what looks to be a Halloween celebration. From left to right are Christine Spinny, Amia Claymoor, Ethel Stine, Ida Breazeale, Ethel Shallenberger, Jude Hixson, Nelle Robertson, Belle Farthing, Harriet Massey, Isabell Alderman, Lul Wernet, and Ethel Moore.

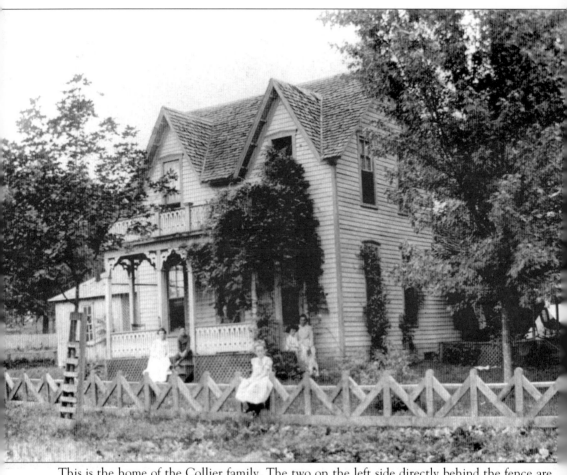

This is the home of the Collier family. The two on the left side directly behind the fence are Mable Prather and Neil Gray. In the front window of the house is Mrs. Collier. Thomas Gray and Mrs. Gray are on the right side of the porch. The little girl sitting on the fence is Lucy Gray.

This was the home of J.J. Williams, and where Gene and Agnes Williams were born. In 1902, this home was torn down after the school was expanded.

This house in 1908 was the home of Lunce (Lance) and Telia Williams. It was located behind the old Western Auto store.

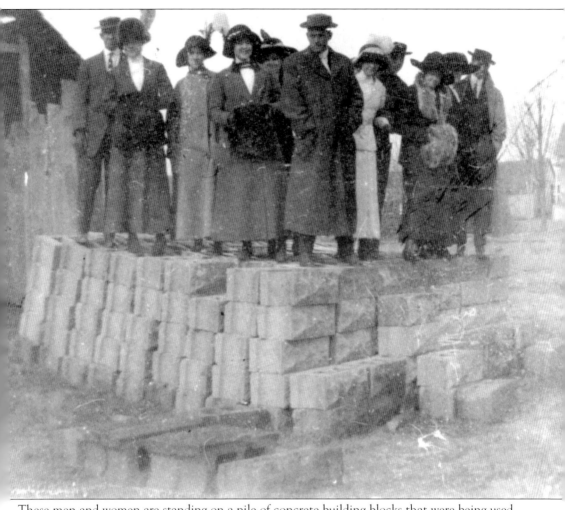

These men and women are standing on a pile of concrete building blocks that were being used for a building that was under construction at the time.

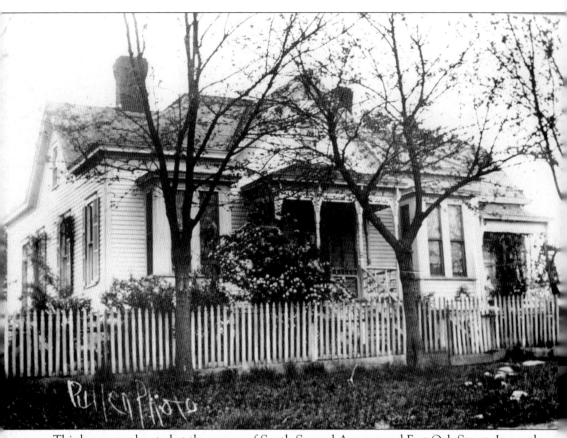

This house was located at the corner of South Second Avenue and East Oak Street. It was the home of Bill Williams.

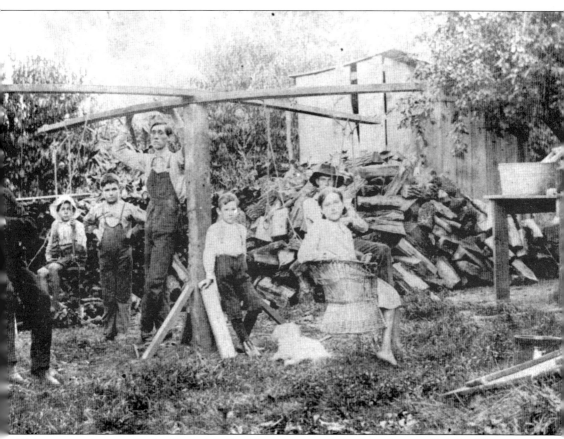

This contraption was in the Karstein's Yard located east of Ozark and was called the "Flying Jenny." From left to right are an unknown man on the swing, Herbert Karstien, Charlie Truett, Elmer Waggoner, Homer Vaughan, Nora Garrison, and the man behind Nora is unknown.

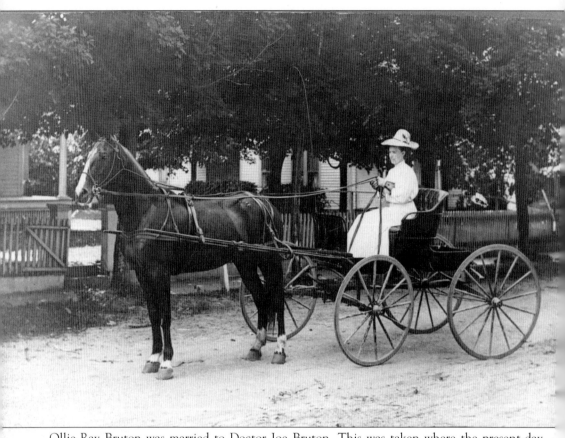

Ollie Ray Bruton was married to Doctor Joe Bruton. This was taken where the present-day Health Department is located, on Brick Street in Ozark.

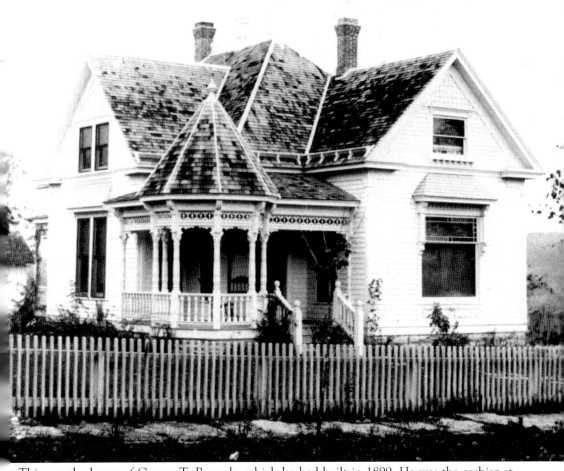

This was the home of George T. Breazale, which he had built in 1899. He was the cashier at the Ozark Bank.

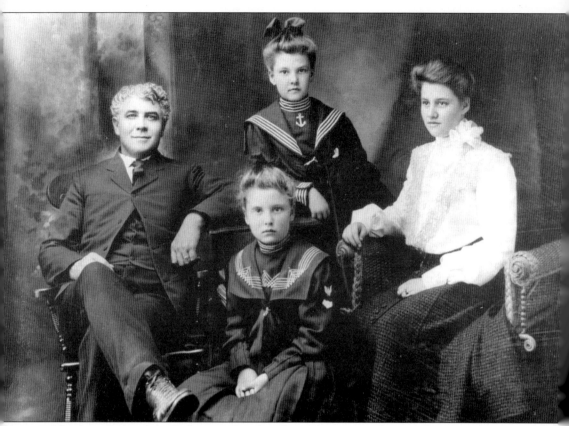

This is a photo of the Robertson Family. The only two people named in this photo are the daughter standing up in back, Lola Robertson, who later married a Thompson, and the mother Lennie Robertson.

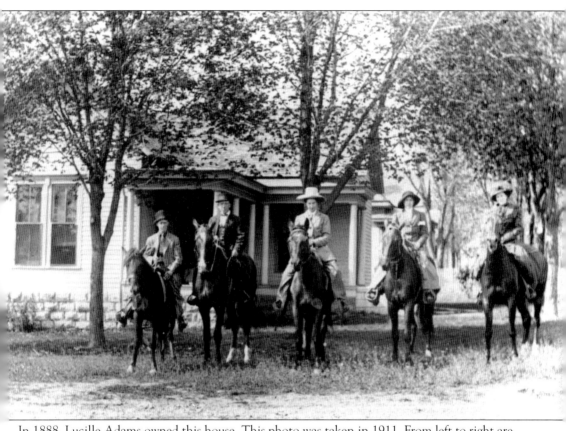

In 1888, Lucille Adams owned this house. This photo was taken in 1911. From left to right are Stanley Clayman, Lynn Duncan, Marie West, Lucille (Adams) Anderson, and Lucy May Gray.

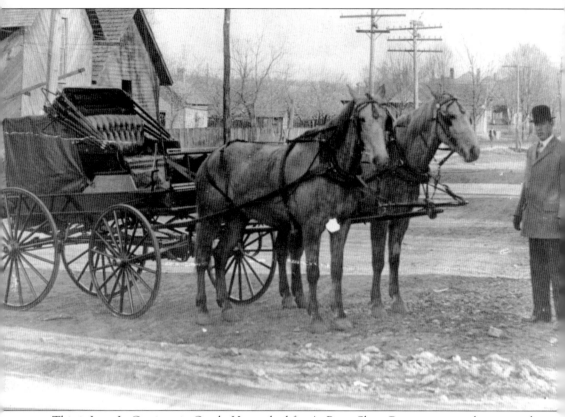

This is Jesse L. Garrison in Ozark. He worked for A. Peter Shoe Company as a salesman with a team of horses from the livery barn. Jesse carried samples of shoes, took orders from residents and traveled many miles to take other orders from merchants in other towns. Since Jesse was gone for several days at a time, he stayed in farm homes and hotels.

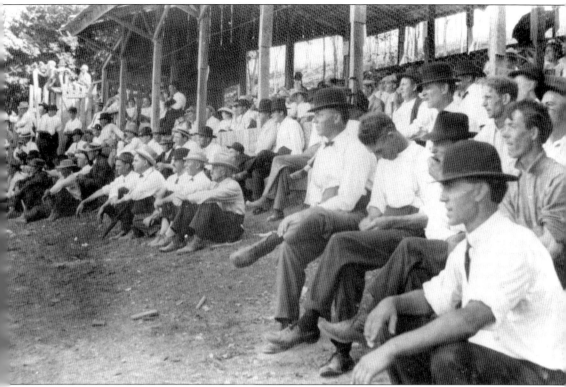

This crowd is intently watching the action of some event, most likely a baseball game.

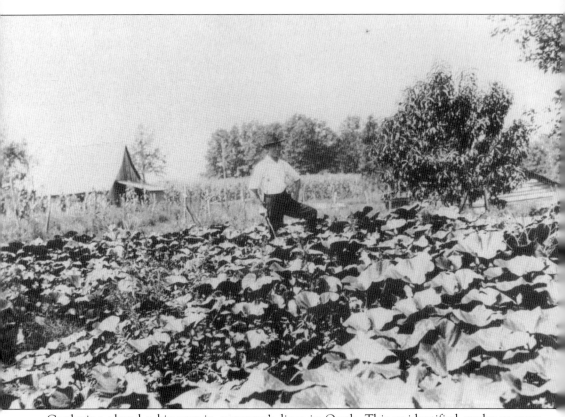

Gardening played a big part in everyone's lives in Ozark. This unidentified gardener poses proudly in his well-tended garden.

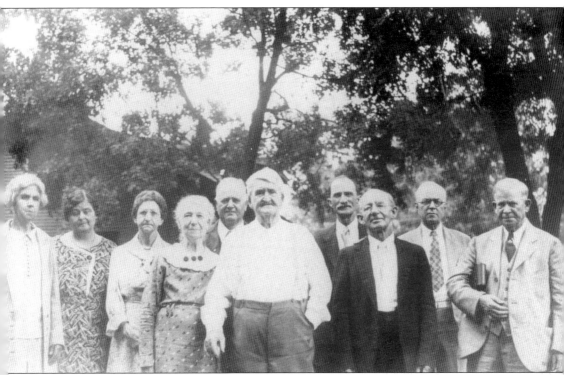

This photo was taken in the year 1936. The people in the photograph are identified as: "Most Front: Bill and Emma H. Woody. Next level: Telia (Williams) Russell, Ivie (Ivy?) Rogers, John Rogers. Back most row: August Spiess, Marck (Mark) Logan, Luther Vaughan, Reggie Merritt, Doc Tom S."

This woman looks to be either
sewing or fixing something.

These three women strike a
serious pose in a front yard.

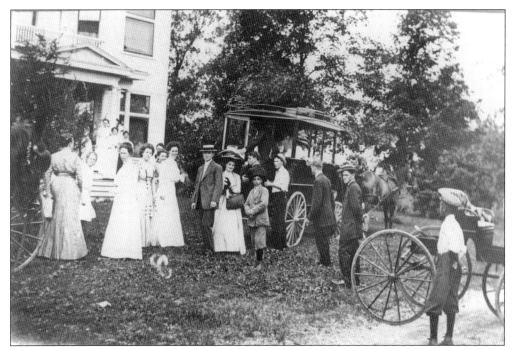

There looks to be a formal occasion at hand for this gathering. Notice the large wooden wheels on the vehicles.

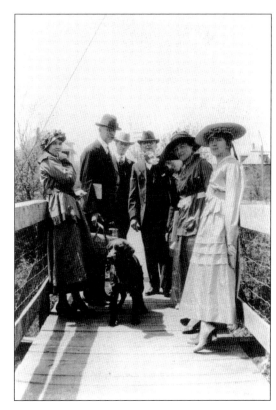

This group is out for the day in Ozark, and paused on the bridge for a photograph, along with their dog.

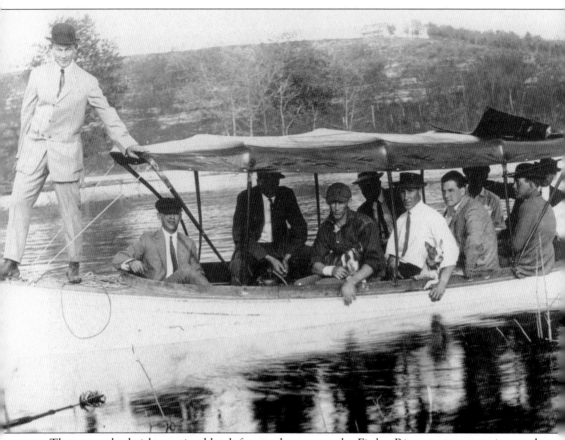

These men had either arrived back from a day out on the Finley River, or were getting ready to leave.

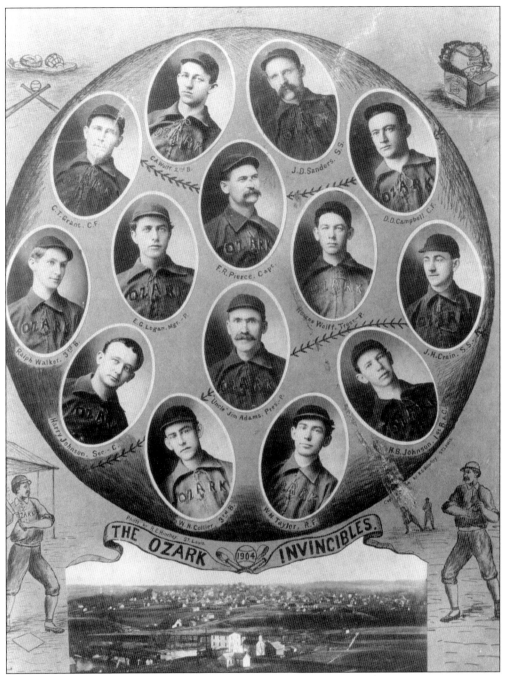

This was the team photo for the Ozark Invincibles baseball team in 1904. The names listed with this photo are C.A. Wolff (Wolf), J.D. Sanders, C.T. Grant, F.R. Pierce, Ralph Walker, E.G. Logan, Roscoe Wolff (Wolf), Harry Johnson, Jim Adams, W.N. Collier, W.M. Taylor, H.B. Johnson, J.H. Crain, and D.D. Campbell.

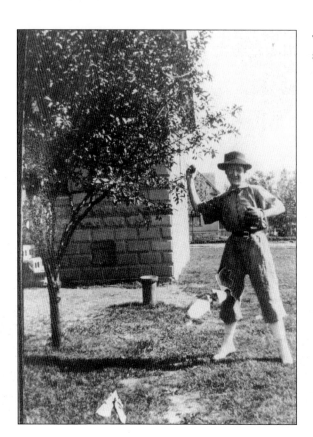

This photo shows that women, as well as men, played baseball.

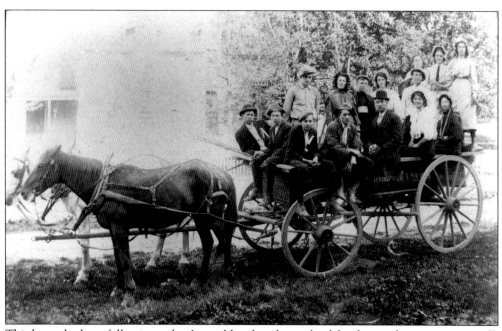

This buggy looks as full as it can be. It would make a heavy load for the two horses to try to pull, but it made a fine place to stage a photograph.

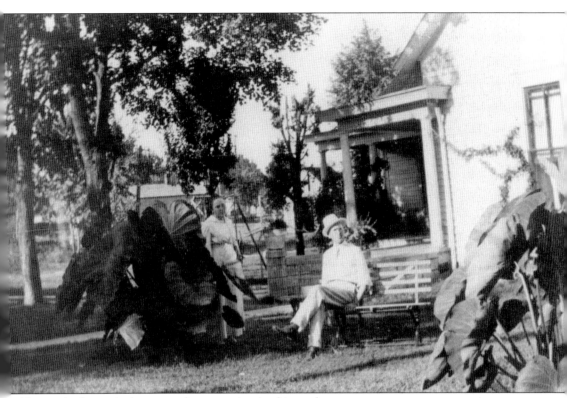

Notice the large elephant ear plants growing in this yard.

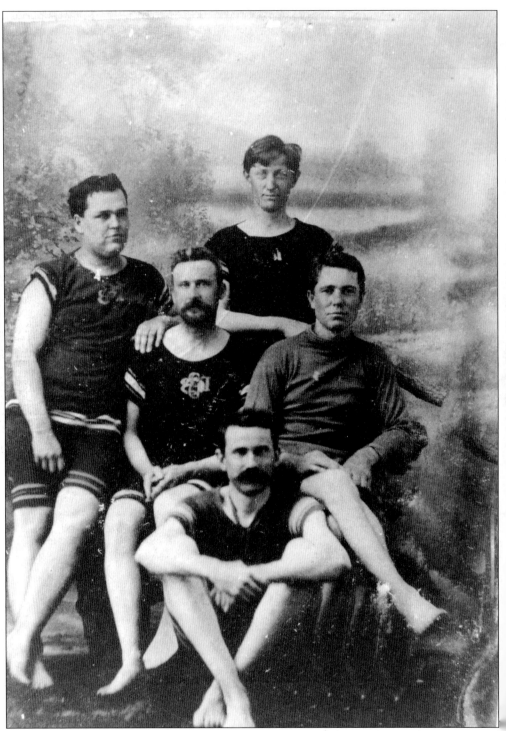

These five men were in their swimwear. They look to have been professional swimmers and members of a swim team.

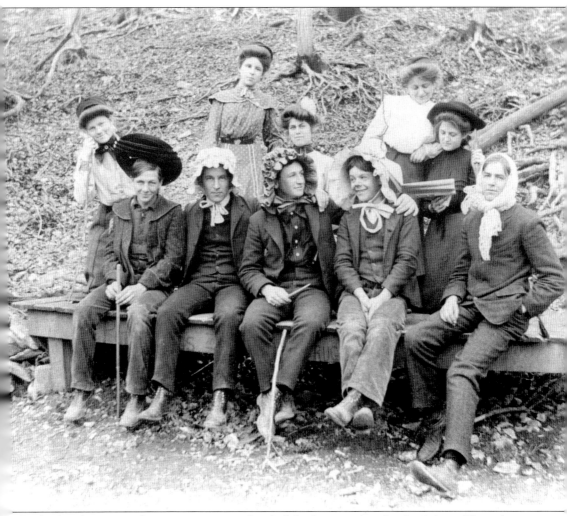

Just for fun the men and women sitting on this deck had swapped each other's hats. The girls are Beatrice Collins, Louva Clay, Ella Yarbrough, Virgie Yarbrough, and Grace Garrison. The real men are Claude Garrison, John Dryden, Frank Henry, Frank Wallace, and Guy Long.

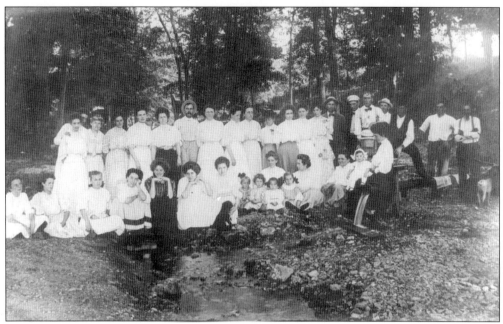

This large group may well be on a family reunion picnic.

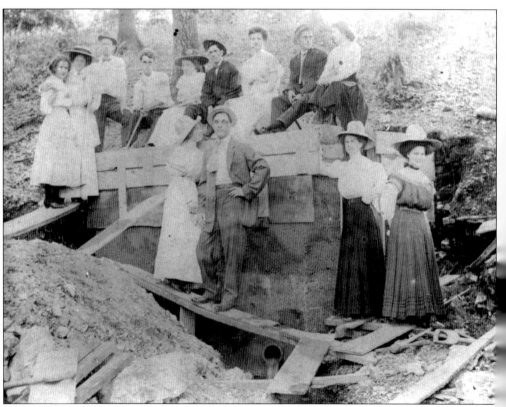

This well-dressed group is gathered on the remains of some kind of collapsed structure; a seemingly odd place to pose for a photo.